COLLINS

PAINTING

WORKSHOP

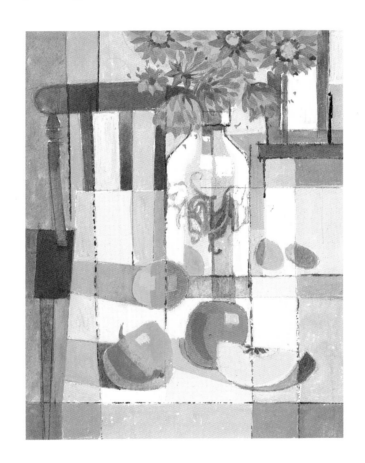

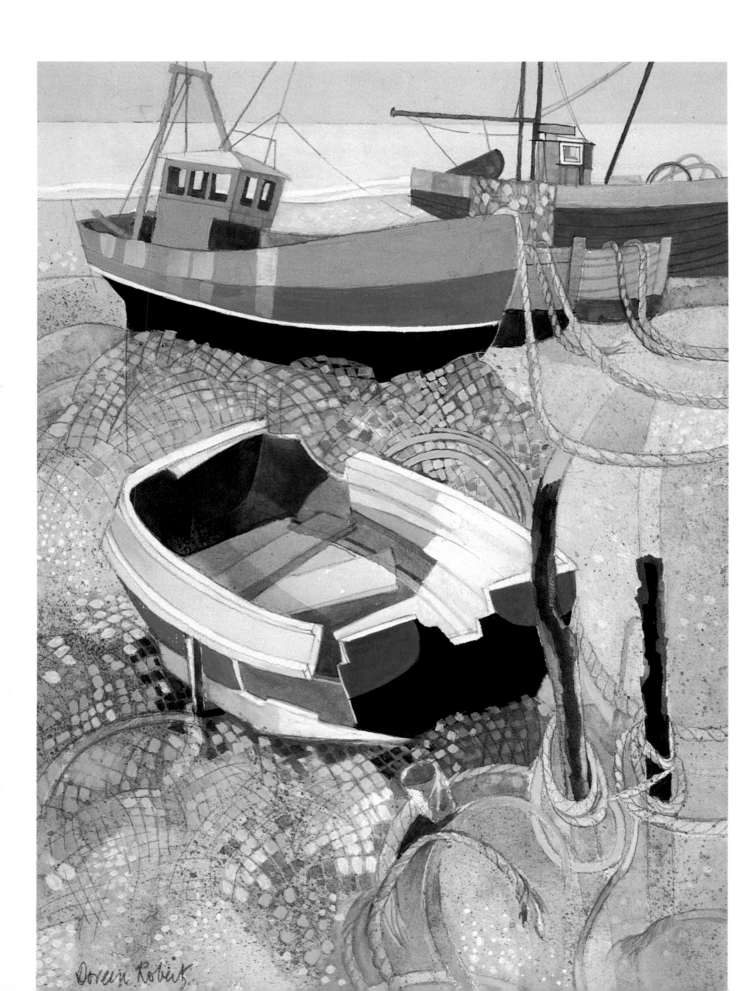
Doreen Roberts.

COLLINS

PAINTING

WORKSHOP

A PRACTICAL COURSE IN PAINTING METHODS TO DEVELOP SKILLS AND CONFIDENCE

Doreen Roberts

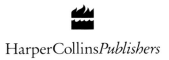

HarperCollins*Publishers*

DEDICATION

For my friends Michael McInerney and
Neville van Hove

Acknowledgements

The illustration by Doreen Roberts from *Joe at the Fair*
is reproduced by kind permission of
Oxford University Press
Gardens in the Snow (Doreen Roberts) is reproduced
by kind permission of Mr Carrick McDonald
Florentine Echo (Richard Plincke) is reproduced by
kind permission of Mrs R. Cheswright

I would like to thank Daler-Rowney for supplying
generous amounts of materials.
I am also most grateful to the following artists
for lending their work:
Alfred Daniels RWS, RBA, Peter Folkes ATD, VPRI, RWA,
FCA (Hon), Moira Huntly RI, RSMA, PS, Ronald Jesty,
George Large RI, Susan Pendered RI, Richard Plincke RI,
Raymond Spurrier RI, ARWA, Shirley Trevena.

My thanks, too, to members of the
Millfield Wednesday Painters.

First published in 1994 by
HarperCollins Publishers, London

© Doreen Roberts, 1994

Doreen Roberts asserts the moral right to be identified as the
author of this work.
Certain aspects of the author's normal teaching methods have
been adapted to suit this series.

**A catalogue record for this book is available from the
British Library**

Editor: Patsy North
Art Editor: Caroline Hill
Photographer: Ed Barber

ISBN 0 00 412678 5

Set in Palatino and Futura
by Wearset, Boldon, Tyne and Wear
Colour origination in Singapore, by Colourscan
Produced by HarperCollins Hong Kong

PAGE 2:
Doreen Roberts,
Broken Boat,
35.5 x 25.5 cm
(14 x 10 in),
gouache

CONTENTS

ABOUT THIS BOOK

The aim of this book is to encourage you to learn by doing, just as you would in a practical painting workshop led by a tutor. You will find here plenty of instructional teaching and general guidelines, but throughout the emphasis is on practical work so that you can begin from the start to develop your own ideas and way of working. As you practise and become more visually receptive and perceptive about the world around you, your personal style can begin to emerge and develop quite quickly.

To help you practise effectively, in each main chapter there are a number of exercises and projects – it is important that you try to carry out all of these before moving on, to ensure that you have understood and practised the teaching.

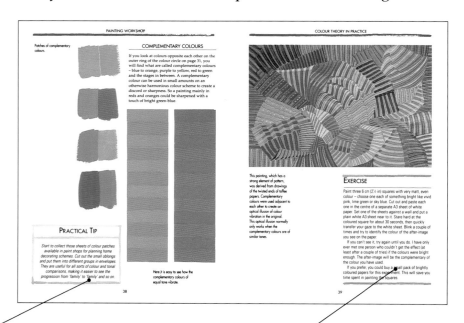

PRACTICAL TIPS
Throughout the book you'll come across practical tips. These highlight some useful hints about working methods and provide a few solutions to everyday painting problems.

EXERCISES
These are designed to complement the teaching contained in each chapter. Some of the exercises are quite short and should not take too long to do; others may require a little more time. Their aim is to get you painting and thinking for yourself.

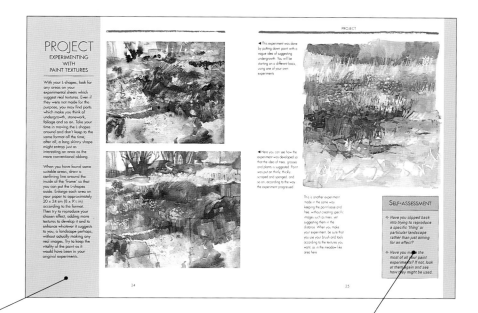

PROJECTS

The projects, of varying degrees of difficulty, concentrate on more specific aspects of painting, with a view to sparking off ideas which you can then try to interpret in your own way.

You should take your time with the projects and be prepared to reread relevant sections of the text as often as you need to enable you to tackle them successfully. After all, there are no short cuts to learning to paint well!

SELF-ASSESSMENTS

At the end of each project, you'll find a number of self-assessment questions relating to the work that you have just completed; these are intended to draw your attention to particular aspects

of your painting, in the same way that a professional tutor might assess your work in a practical workshop.

IDEAS & INSPIRATION

The paintings in the book, by the author and other well-known contemporary artists, cover a wide range of

different subject matter. Some of these paintings are meant to complement and clarify points explained in the text, but others are included to

show how style and technique vary from one artist to another, emphasizing the importance of being original in your creative

work. They can help you to extend your attitudes and horizons – and fire your enthusiasm. They are there for you to enjoy!

INTRODUCTION

Why do people want to paint rather than learn sculpture, printmaking or any other branch of the visual arts? Usually because they like the idea of using paint as a medium and think it would be pleasant to make 'pictures'. Many assume that they have to learn special techniques before they begin to paint. This is not so, and it is unwise to be fixed in one's ideas about this. What is essential is to be able to handle paint in your own way and to be able to express what you find interesting about your subject. By talking in terms of techniques, one is 'naming' and therefore limiting. It is better to get on with the doing and leave words to the writer. Painting is a visual language.

Doreen Roberts, *Afternoon Mist*, 35.5 x 46 cm (14 x 18 in), gouache. The original drawing for this painting was made waiting in a car for the mist to clear and reveal what was hidden.

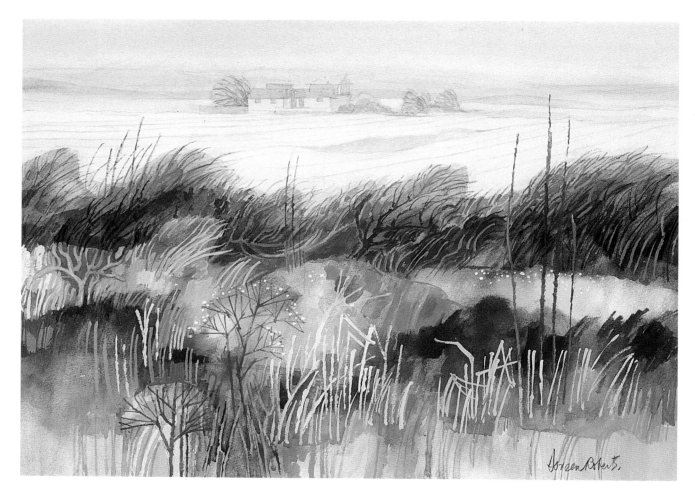

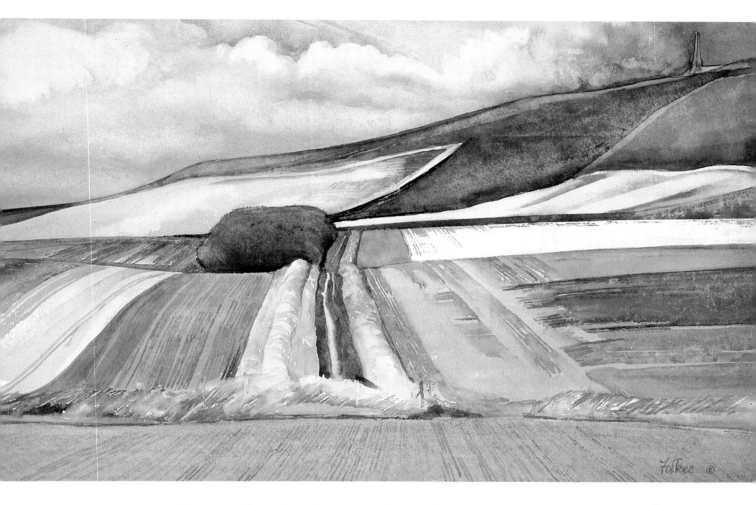

Every tool and medium you have should be exploited as far as possible so that you have a wide 'vocabulary' to work with. Every mark you make is like a word to a writer, a note to a composer – anyone who wants to communicate an idea. Writers and composers arrange their marks in a logical way according to their particular language. In the same way, it is our ability as painters to arrange our colours, shapes and textures effectively for our purposes which makes us creative artists rather than imitators or mere observers. Your audience should be able to 'read' your language and so understand what you are communicating about your subject. Understanding, of course, does not necessarily mean liking any more than we like all the books we read or the music we hear. Liking is subjective, but 'good' and 'bad' are judgements and should be objective, stemming from understanding and knowledge.

For beginners to painting, it can be difficult to decide which medium to use. For the purposes of this book, I have chosen gouache as my teaching medium because it is a multi-purpose, versatile, water-based paint and can be mixed with various other water-based media. It can be used

Peter Folkes,
Downs and Monument near Calne,
38 x 56 cm
(15 x 22 in),
watercolour

9

transparently or opaquely and in conjunction with crayons and other materials and tools, and is good for altering parts of a painting which are not satisfying or for changing one's mind in mid painting. It is very easy to use, is relatively cheap and very little is needed in the way of other equipment, so it is a good medium for beginners to establish the general foundations of painting. For those who want to try another medium later on, I have included a chapter on using two other water-based paints – acrylics and watercolours – and throughout the book I have shown illustrations of my own paintings and those of other artists worked in various media, so that you can see the different effects.

If you wonder whether it is necessary to be able to draw before you paint, the simple answer is 'yes', because drawing, although it cannot be seen, is implied in painting and is evident in a composition.

Ronald Jesty,
*Kimmeridge
Ledges,*
28 x 76 cm
(11 x 30 in),
watercolour

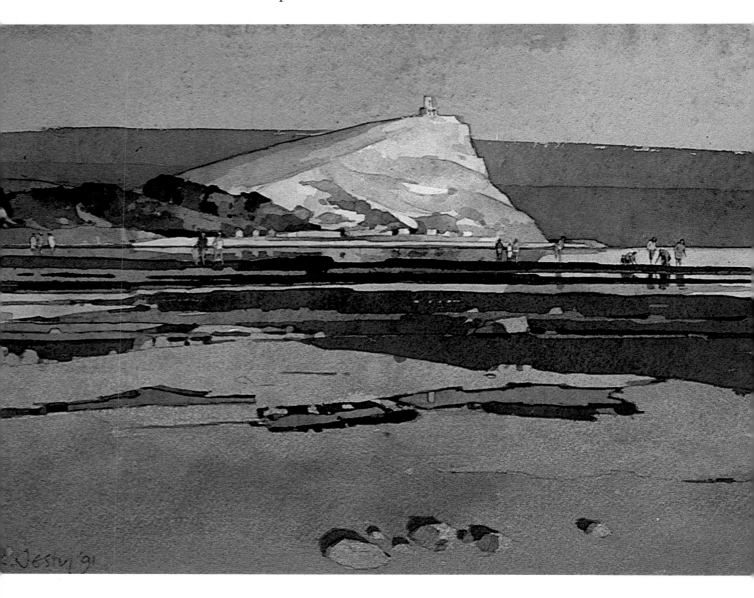

Before you begin, it is very important to understand the style of my teaching. I don't believe in painting by example nor by the 'how-to-do-it' method – after all, what is the use of trying to paint like someone else? Not only are they different from you, but their demonstrations are usually the result of a lifetime's work. Contrary to general belief, in my experience it is very difficult to wean oneself from strong influences and easy solutions and to develop one's own solutions afterwards, since attitudes and methods have to be unlearned. So try from the start to be original in your creative work and to develop your own individual style.

I hope that you will enjoy the learning process, finding the courage and passion to begin if you have never painted before, and to progress if you are already painting but are in a rut or want to change your medium or your methods. Take your time and explore all the options.

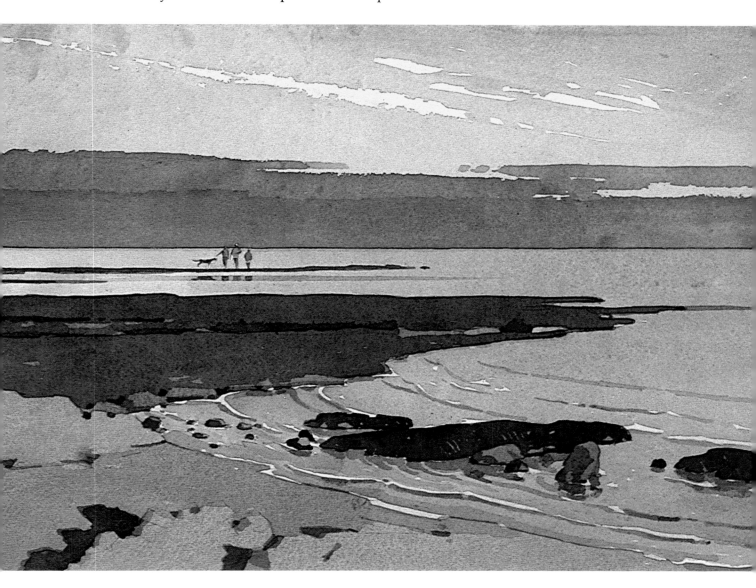

MATERIALS

At first, going into an art shop can be quite bewildering, and the array of attractive sets of paints in all sorts of pretty packaging, pens and other materials can be very tempting. Don't be seduced by these! It can be a waste of money to buy sets of anything as they are likely to include what the manufacturer thinks you need – after all, they can't know individual requirements. In sets of paints there will often be colours that you don't need and not those that you do. For most materials it is best to select items individually and as you need them. For economy, plastic food boxes, which come in all shapes and sizes, are ideal for storing colours and pencils, and the long thin ones will hold brushes.

Wait until you know your basic needs before you go to an art shop, and do your own selecting. Many shops have assistants who, like the manufacturer, will give you what they think you need. A student of mine asked for a plastic eraser and was sold a putty one, being told they were the same thing. They are not, and she wasted her money. So beware!

This shows how a basic selection of colours with two siennas are set out on the rim of the palette. The L-shapes are isolating an interesting area of a notebook page.

BRUSHES

Brushes come in a range of qualities and prices, and are graded in named or numbered series. Round-ferruled and square-ended brushes are both useful when you are learning to paint; good sizes as starters are no. 7 or no. 10 round and 1 cm (⅜ in) and 1.25 cm (½ in) square-ended. The most useful brushes for gouache, as for watercolours, are top-quality pure sable, but as these are very expensive, brushes made of a combination of sable and synthetic, or pure synthetic hair work well as an alternative. It all depends on your purse and preference.

All round-ferruled brushes should have a good point and be springy, not floppy. Real hair or hair mixtures should be tested before you buy. Be particular about this; if your art shop doesn't offer a pot of water or supply it on request, go somewhere else. All good art shops will have this facility. Swill a chosen brush in the water to clear away any glue, then shake off the excess water on the floor (watch where you do this!) and flick the brush tip hard across your thumbnail. Do this several times; if the brush does not retain its point, try another until you're satisfied. Square-ended, soft-haired brushes should also be tested (swill and shake) to see that the hairs don't separate laterally.

This study of a red pepper cut in half shows gouache used thinly as with watercolour.

PALETTES

A white enamelled camping-type plate with a rim (from camping or hardware shops) makes a convenient and practical palette. I have used one for the last thirty years for both gouache and acrylics. Personally, I find that most purpose-made palettes assume we work in specific ways, and decide for us how many colours we need and where to put them. Some also stain badly. An enamel plate is more versatile, less expensive and stainproof. However, in this case the choice is yours, so use what suits you best.

PRACTICAL TIPS

Kitchen roll cylinders serve well as brush holders if one end is sealed.

To keep your brushes safe, cut a strip of sturdy card measuring about 24 x 5 cm (9½ x 2 in) and use an elastic band to hold the brushes on either side of the card.

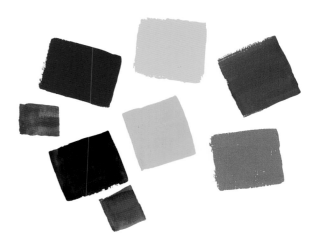

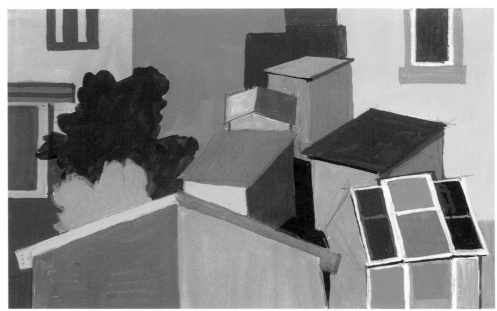

The matt and flat colour patches above show the six recommended basic colours. They are also shown used thinly and wetly so that they combine at random. The small painting (right) has been made using the colours flatly, some mixed together and some mixed with white.

COLOURS

Many artists recommend the colours they personally use and for no particular reason except that they suit their own work. This can be restricting while you are learning; it is better to have a limited general palette and add to this as you discover your own needs. I aim to keep costs as low as possible – but, of course, people with less limited budgets can always spend more if they wish.

BASIC COLOURS
Whether for gouache or for any other medium, I recommend buying a 'hot' and 'cold' version of the three primaries – red, yellow and blue – with the addition of Zinc White or Titanium White (buy a double size of white). I do not recommend black as really dark colours can be mixed just as successfully and with more vitality without it, and the inexperienced use of black can make colours look dingy.

Hot version	Cold version
Golden Yellow/Brilliant Yellow	Lemon Yellow
Alizarin Crimson/Crimson	Flame Red/Vermilion
Ultramarine	Prussian Blue

The reason for this selection is that most of the everyday colours can be mixed from these examples. If you want to add some extra colours to your selection, you will find Raw Sienna and Burnt Sienna useful. For luxury if and when you

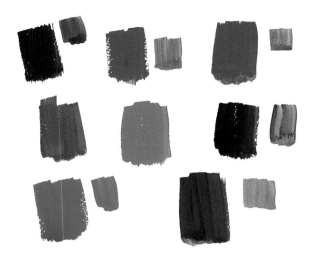

These colour patches show the useful browns and other extra colours applied in the same way as on the previous page. The same subject as before is repeated (left), this time painted in the extra colours only.

feel like it, try Winsor Green, Cobalt Blue, Phthalo Blue, Indigo, Havannah Lake or, Rose Tyrien/Magenta, but stay with the basics until you have discovered more about what you can do with them.

Manufacturers all have their own trade names for colours and they vary, so check with their individual charts for these. Most painting media are priced according to Series numbers which can be found somewhere on the tube label. Look at these before you buy and check how each brand is marked as this affects the cost. For example, in Designers' Gouache, Series 1 or Series A are the cheapest, but in one brand of paint Flame Red may be put in Series 1 and in another brand, in Series B.

PRACTICAL TIP

In all media, tubes will harden with time, even with frequent use. Never store your paints in the sun or near heat sources. After each squeeze or session, dip the neck of all tubes used into clean water before screwing the top back on.

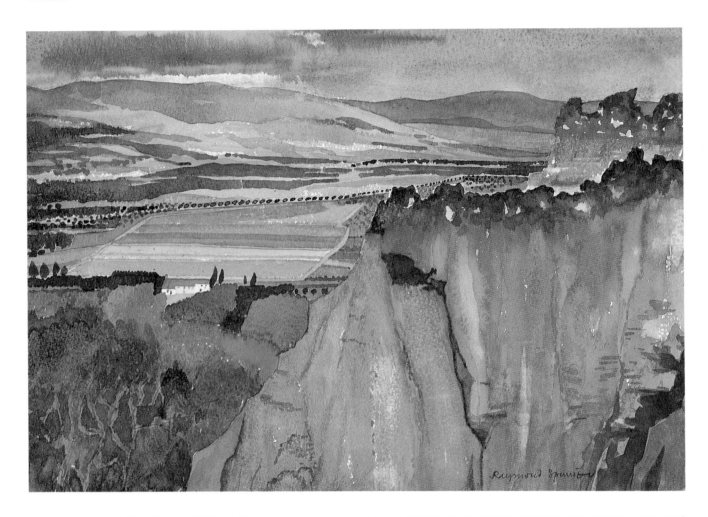

PAINTING SURFACES

Good cartridge paper will do for experimental
or small work, otherwise you can use any paper
or board suitable for watercolour. I personally
use boards surfaced with watercolour paper, but
only for major work. Watercolour papers usually
come in three surfaces: Hot Pressed (smooth),
Not (reasonably smooth, but with a 'tooth') and
Rough. Bockingford paper has only one average
surface. All papers come in a variety of different
weights, ranging from roughly 190 gsm (90 lb) to
640 gsm (300 lb).

It is always more economical to buy several
types of paper in sheets rather than in pads as a
pad will contain only one size and type of paper.
Cutting an A1 sheet into two creates A2 size and
into four, A3. Never keep your paper rolled up;
open it out and cut it into at least A2 (or half
Imperial), keeping the sheets flat in a folio or
between two pieces of card.

PRACTICAL TIP

*From any sheet of paper you buy, cut a 3 cm
(1¼ in) strip across its width and on it write its
name, weight, make and surface, together with
any findings you have from your experiments. It
is a good idea to try a few textures and colours
on each strip too – in pencils and crayons as
well as paint. If you clip all the strips together,
you will always know exactly what you need to
buy for whatever job you want to do.*

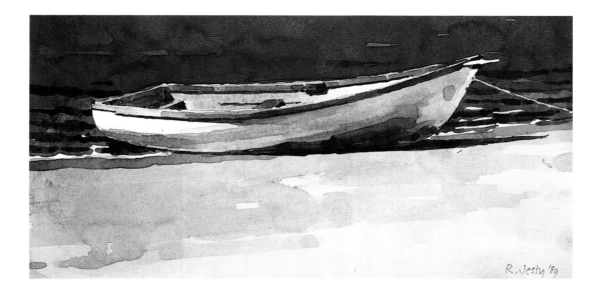

◀ Raymond
Spurrier,
*Roussillon,
Vaucluse,*
24.5 x 34 cm
(9³/₄ x 13¹/₂ in),
watercolour

▶ Ronald Jesty
Beached Boat,
18 x 35.5 cm
(7 x 14 in),
watercolour

STRETCHING PAPER

Many painters say that 300 gsm (140 lb) paper or thicker needn't be stretched to prevent cockling when paint is used wetly, but I stretch everything up to 640 gsm (300 lb); the thicker papers bend rather than cockle. Some painters never stretch any paper at all – it's a matter of personal preference.

If you have not tried stretching paper before, practise first on some old drawings you don't want or on any sort of spare paper. You will need a board at least 5 cm (2 in) bigger all round than your paper. The most economical is 9 mm (³/₈ in) or 9-ply thick plywood cut to your requirements. Sandpaper the surfaces gently to remove any grease. You will also need gummed tape (the kind that you wet to make it stick) and a clean, soft tea-towel. Pre-cut four strips of tape about 5 cm (2 in) longer at each end than your paper. Take everything to a flat surface close to your sink.

Either soak the paper for a minute in the sink or (as I do) hold it under the running tap, moving it about so that the water runs over both sides of it. Lay the paper on your board and leave the tap running. Place the tea-towel carefully on the paper and pat lightly and gently. Quickly run each strip of tape under the tap and tape down the four sides of the paper. Pat firmly but gently with the towel. Don't rub or you'll wreck the paper surface. Leave flat to dry.

If you are slow in getting the tape down and the paper begins to cockle too soon, look at the direction of the cockle. If it runs the length of the paper, lift one of the long sides gently and pat it down with the towel from the opposite side as you re-lay it. If the cockle runs across the width of the paper, lift one of the shorter sides and pat down the paper as before.

If you are using really thin paper, it will cockle all over. In this case, avoid blotting it with the cloth but get the tape down fast and blot that instead. Avoid pressing any bumps in the paper.

Removing a
lengthways
cockle when
stretching paper.

OTHER USEFUL EQUIPMENT

A roll of drafting tape, not masking tape which is of higher tack and could pull away the surface of your paper. Don't let your shop tell you that they are the same or will do the same thing.

Pairs of L-shaped pieces of card in two sizes. Guidelines for sizes: Small pair, width 5 cm (2 in); outside length of arms 16 cm (6¼ in). This size should fit into a sketch book for carrying. Large pair, width 12 cm (4¾ in); outside length of arms 40 cm (16 in). These are useful for selecting areas on work and checking composition. Using L-shapes is dealt with in the next chapter.

Two waterpots, one for swilling your brush in and one into which to dip your cleaned brush.

In addition to these materials you can collect or buy a few useful things to enhance your textural surface. All these odds and ends can be kept in a separate plastic box.

A box of flat tissues, which are more convenient than a roll. You can buy cheap toilet packs, but they must be the soft, absorbent kind. Tissues are useful as paint rags or for dabbing or wiping on a painting – and, of course, to wipe the centre of your round plate while the squeezed-out colours around the rim are left clean to be used.

An old toothbrush for splattering paint.

Some cotton buds.

A piece or two of household sponge.

A piece of wax candle and/or some oil pastels.

Watersoluble pencils or crayons.

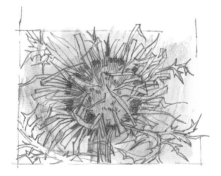

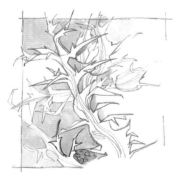

Rough idea for a possible painting from a dried flower head and leaf, using different media – watercolour pencil, graphite and watercolour.

PRACTICAL TIPS

It is a good idea to use an old tea tray, especially one with handles, to hold your equipment and store it somewhere accessible (on top of a cupboard?) so that you don't have to keep putting away and getting out your paints. In this way you can make the most of short spells of time for doing some experiments and exercises. Frequent practice is more fruitful than waiting for long periods until 'you have the time'.

If you buy yoghurt or anything else in 500 g tubs, rinse and keep these for water so that, as a pot gets too grubby to clean, you can throw it away and take a fresh one. They stack easily until you need them.

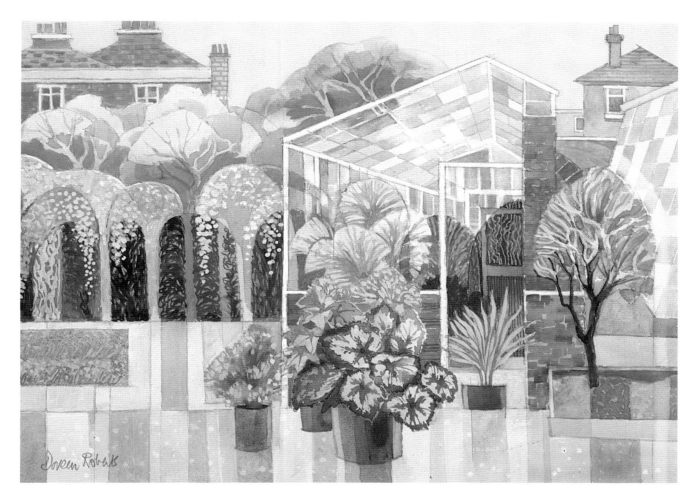

WORKING POSITION

Doreen Roberts, *Greenhouse*, 35.5 x 25.5 cm (14 x 10 in), gouache.
Shapes and objects were simplified so that the decorative qualities and the relationships between plants and buildings were more noticeable.

Make sure you have the right basic equipment and then decide where you are going to work most of the time. You will benefit by giving this some thought. Resting your drawing board against a box or books on a table is fine, as is resting it in your lap and against the table. Wooden table easels are not too expensive and the height is adjustable. Whether you work with one of these or with a free-standing easel, check that your posture is correct when you are actually painting, as any length of time spent in concentration can lead to physical tension. Make sure that you can get up and move away to look at your work without much struggle and that your chin is not pushed forward by having your board too high or far away.

When you have collected a nucleus of materials and found your best working position, it is time to begin painting.

USING PAINT

Rather like the first visit to an art shop, making a start at painting can be quite daunting. Even those who are more advanced admit that they can be intimidated by a pristine sheet of paper.

Take heart, though. Gouache can be sponged out and painted over so that mistakes or changes of mind are not disastrous. Working from this book, too, is not like being plunged into a class where everybody seems to be getting on with 'their own thing'. Take your learning process one step at a time and base your attitude on the well-used quotation 'To travel hopefully is a better thing than to arrive, and the true success is to labour.' Of course we want to 'arrive' – whatever that is – but in the meantime just enjoy learning, re-learning, or developing new approaches.

MAKING A START

Lay out your colours round the edge of your plate or palette; the centre of the plate is used for mixing and it can easily be wiped clean without wasting the paint supply. Always put out your colours in the same order, from light to dark or vice versa, each time you prepare for work, so that in time you will know exactly where your colours are without having to look for them. (Check with the illustration on page 12.) If you are not using all your colours at first, leave spaces for the others in case you want to add them later. When you are making your initial experiments, don't be mean with your paint. If your quantities are too small, you will not feel the freedom which you need for your new discoveries.

Make sure your brushes, waterpots and colours are near your working hand and that tissues and palette are near your other hand ready to be picked up. You will soon find the most convenient positions.

▶ An experiment with gouache used in different ways to suggest a landscape.

FIRST EXPERIMENTS

For these experiments place your paper on a board and have this *flat* on your table so that you can stand up to paint. Take a rest at intervals to straighten your back. Now is the point at which you should experiment with whatever paints, tools and texture-making odds and ends you have around the house. If you have only gouache available, with no crayons, watercolour pencils and so on, give yourself a free rein and push the paint to the limits of what you can discover. If you have a lot of other oddments, try everything separately and then in combination, as in the illustrations in this chapter. Don't try to make recognizable images or approximations to things you have seen; merely deal with the qualities and possibilities of the paint itself.

◄ This first experiment shows how you can splash on the paint, drop it, use it wet into wet or wet on dry, thick on thin or vice versa. You can scrape, push, splatter, comb and wipe it, apply it over candle grease or dab it with your fingers.

▲ Here the colours have been rubbed together or allowed to run in a calculated way by tipping the paper. Cover the whole sheet; don't make isolated patches with white in between. Where experiments overlap, they can create new ones.

Just have fun. The most important thing here is that everything you try should be done with awareness and the result of every action should be noted. If you don't do this, then the experiments will be just a pointless game. The aim is to find all possible effects so that you can reproduce them again at any time. It's a tall order and needs a lot of work, but the learning is fun and will widen your technical ability. After this you won't need to ask 'How do you put paint on?' The answer is 'Any which way that suits the job in hand.'

▲ Here the differences between splattering, sponging, brushwork and painting over greasy crayon can be seen clearly.

▼ Notice how the L-shapes are used here to isolate an area of particular interest. Remember that large L-shapes can be used with their ends overlapped if necessary.

DEVELOPING THE EXPERIMENTS

When you have a stack of sheets covered with paint experiments, they will look a real mess, so isolate any areas that seem to you particularly interesting in terms of colour, texture and general effect. Do this by using your L-shaped cards; move these around your work, making rectangles of varying proportions until you see something interesting. When you do, draw the outline of the rectangle on the painted surface and then find another – as a rough guide, the size of the areas you are isolating should be around 6 x 10 cm (2½ x 4 in). Try to select those which are also 'comfortable' in composition. At first you will do this from instinct, but later you will become more expert at spotting balanced and interesting arrangements and effects.

Now here's the difficult bit! Try to reproduce each chosen area as exactly as possible by recalling the tools, colours, consistencies and hand movements you used. When you can reproduce effects at will, you will have discovered a whole vocabulary which is your own rather than someone else's.

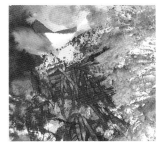

▲ Three interesting areas chosen from the previous experiment.

PROJECT

EXPERIMENTING WITH PAINT TEXTURES

With your L-shapes, look for any areas on your experimental sheets which suggest real textures. Even if they were not made for the purpose, you may find parts which make you think of undergrowth, stonework, foliage and so on. Take your time in moving the L-shapes around and don't keep to the same format all the time; after all, a long skinny shape might entrap just as interesting an area as the more conventional oblong.

When you have found some suitable areas, draw a confining line around the inside of the 'frame' so that you can put the L-shapes aside. Enlarge each area on your paper to approximately 20 x 24 cm (8 x 9½ in) according to the format. Then try to reproduce your chosen effect, adding more textures to develop it and to enhance whatever it suggests to you, a landscape perhaps, without actually making any real images. Try to keep the vitality of the paint as it would have been in your original experiments.

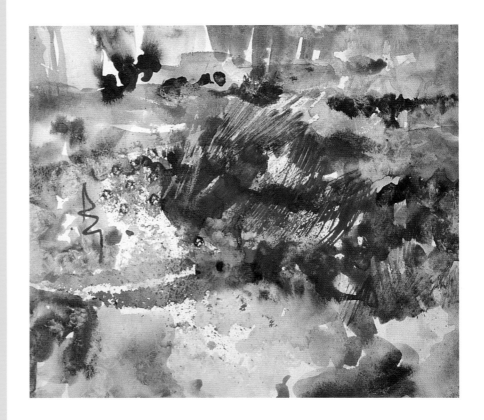

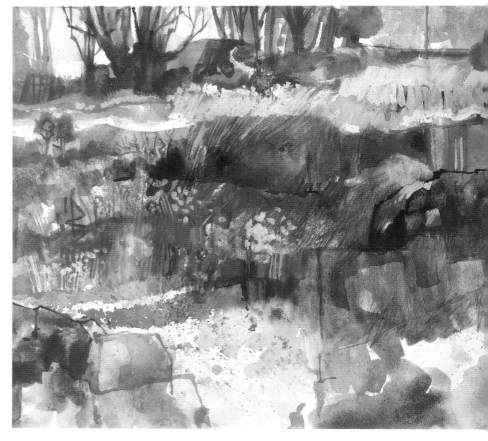

◄ This experiment was done by putting down paint with a vague idea of suggesting undergrowth. You will be starting on a different basis, using one of your own experiments.

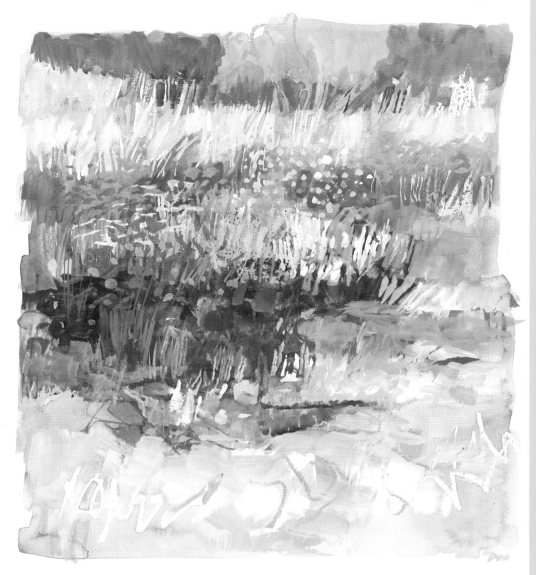

◄ Here you can see how the experiment was developed so that the idea of trees, grasses and plants is suggested. Paint was put on thinly, thickly, scraped and sponged, and so on, according to the way the experiment progressed.

This is another experiment made in the same way, keeping the paint loose and free, without creating specific images such as trees, yet suggesting them in the distance. When you make your experiment, be sure that you use your brush and tools according to the textures you want, as in the meadow-like area here.

SELF-ASSESSMENT

✧ Have you slipped back into trying to reproduce a specific 'thing' or particular landscape rather than just aiming for an effect?

✧ Have you made the most of all your paint experiments? If not, look at them again and see how they might be used.

If you learn to observe trees and the way the foliage catches light and shade, you will find that trying to paint a tree is not that alarming. Always start light and do not use your paint too thickly.

Having blocked in the main dark and light areas, it is possible to refine and use paint textures to suggest masses of leaves without painting detail.

FLAT AND MATT

When they progress to making paintings of specific subjects, some people forget all about their experiments. You will have seen from these and the illustrations here that the paint may be used thinly or thickly, transparently and opaquely – but don't confuse your media. The transparency of gouache is different from that of watercolour, being slightly more grainy (which can be very useful).

Sometimes you will need to use your gouache opaquely, not only in your paintings but when making patches to decide on a colour scheme. Make sure you can put it on so that it is absolutely flat, even and matt.

EXERCISE

Take some clean, flat newspaper and use this to paint on. Try putting down single brush strokes of various colours and put one colour touching another while both are still wet – without them running into each other. Be careful to control the amount of water you use. See, too, just how many colours you can make. Try not to think in terms of names of colours, just mix.

If the print shows through, your paint isn't thick enough; you should be able to cover it. You will find that the yellows have less covering power if they are used on their own, whereas the addition of white improves this. When you can judge the right degree of paint thickness you require, it will help with the experiments in the next chapter.

► Here the paint was put on thinly to establish the lights and darks, and the main elements of the landscape.

▼ Additions were then made to the previous stage: the clouds were darkened and other areas refined.

▼ Here the sky was deliberately lightened to show that darks can be overpainted with lighter colours. Other details were added – these should always come last.

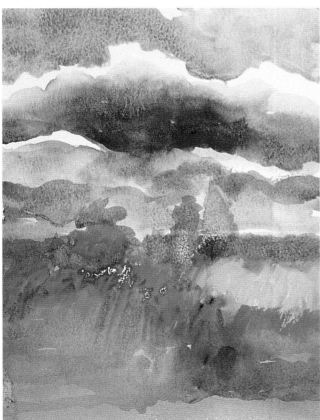

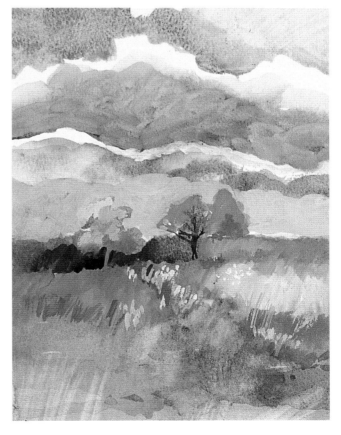

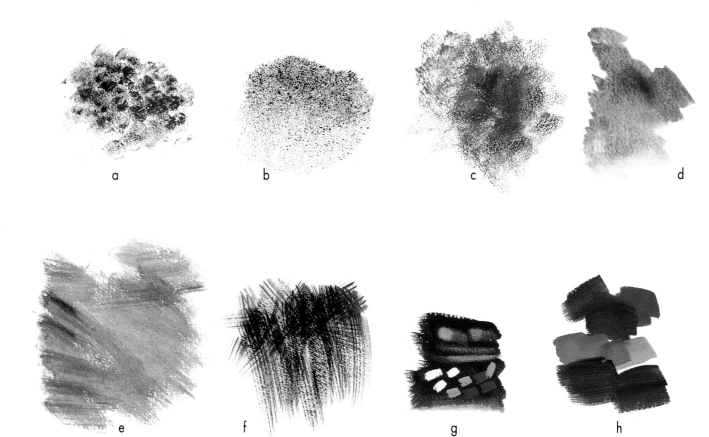

Various techniques are illustrated here:

a Finger prints
b Splattering with a toothbrush
c Dabbing with a small square piece of household sponge
d Wet into wet
e Paint used fairly dry
f Dry brush
g Sponging out and light on dark
h Overlapping brush strokes

RELATING TEXTURE TO SUBJECT

Although a few well-known techniques are shown here, it can be a mistake to rely too much on named 'techniques'. The temptation is to fit your work into these known techniques rather than find new or alternative ones. It is better to work out for yourself what you want to do and then to draw on your own personal way of making marks. Let your hands, your visual memory for textures felt or seen, your body movements and your feeling for the tactile quality of paints and tools provide ways of putting on paint. These are the most appropriate techniques and usually can't be named because they are a mixture of personal methods. Sometimes the conventional 'named' methods will be useful, but they shouldn't be learned separately as 'things-to-know-before-I-can-start-painting'.

If you are not yet confident about finding ways of making specific textures rather than general ones, look back and do the project on page 24 which is a sort of half-way stage to this

PRACTICAL TIP

Date all your work on the back together with any written constructive comments for future reference. This information will help to chart your development and the experiments themselves can be used as reference.

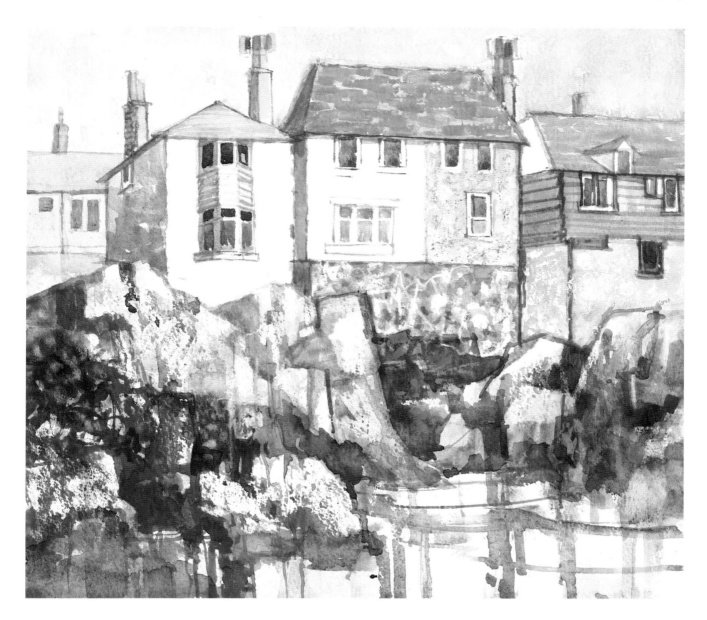

problem. After this, go into your garden or the local park and select a small area of real textures – rocks or stones, gravel, a mass of foliage, ivy and so on. With a pencil (possibly a 6B) make whatever notes you can to show the main shapes and textures. Only choose a small area to start with.

At home try using any media and tools – paint, crayons, brushes, twigs, a sponge – to suggest this particular section of your environment. Have as many tries as you like until you feel satisfied. Try a number of different ways to show the surface rather than try to 'correct' an effort which doesn't work. After this, check on all the exercises to see your progress.

This small painting of houses and rocks was made from a pencil sketch done years before. Greasy crayon, a sponge, a toothbrush, fingers and a twig as well as brushes were used as tools and medium. The textures here are the result of the way these were manipulated. If they had been used in other ways, the appearance would be different, although the subject would still be houses and rocks.

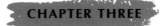

COLOUR THEORY IN PRACTICE

If colour theory is learned in an academic way, it can be really off-putting. Its language is peppered with words like 'wavelengths', 'refractions', 'rods and cones' and so on, so that leisure painters or beginners just retreat, feeling a failure before they even begin.

Many people go through life seeing colour around them, but without really understanding how it works or realizing what effects and moods can be created with it. If you take an intelligent and perceptive interest in colour, you will gradually come to understand it by observing different colour relationships and the effects of light for yourself. Don't be inhibited by what other people think. Most theory is simple enough to explain using ordinary words and a colour circle as shown in this chapter.

An illustration by Doreen Roberts for a children's book, *Joe at the Fair* (O.U.P.) Variations on the three primary colours have been used here as well as greens.

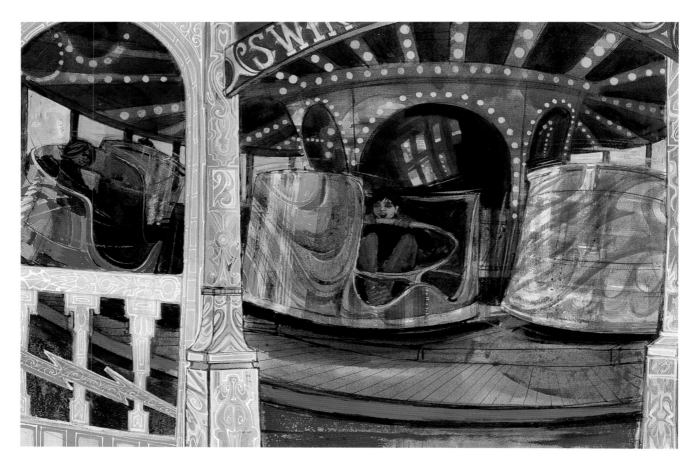

Look at the colour circle here. The three colours in the centre are the primaries: red, yellow and blue. The next three are the secondaries, which are mixtures of the primaries: orange (red + yellow), purple (red + blue) and green (blue + yellow). The points of the triangles indicate where the colours come on the outer circle, which shows the stages of development from yellows to reds, to blues, to greens – the more blue one adds to yellow, the greener it gets until it becomes blue, and so on. Each stage could be broken into smaller ones, but this scale shows enough for a basic understanding.

THE COLOUR CIRCLE

One way to sort out some of the problems in learning to use colour is to refer to a colour wheel (or circle). Once used and understood, there is no need to cling to it for help as the theory is fairly straightforward in principle.

Even if you have access to a colour circle in a book, it is still a good idea to make one of your own as you will be using paint in a different way and learning to match colours. So why not make one before you move on in the text? Paint it onto fairly sturdy paper or thin card, using the example above as a guide. Be careful to match the colours exactly.

Reminder For this and all the colour experiments in this chapter, the paint must be put on absolutely flat, even and matt. You practised doing this in the last chapter, so do remember to put it into action. If you are still unsure about your technique, try out the experiments in this chapter on some sheets of newspaper first.

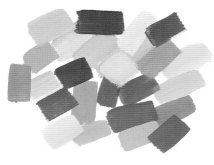

Here the paint has been put on flat and matt.

ART LANGUAGE SIMPLIFIED

For the purpose of this book I have used words which relate to our reaction to and perception of colour rather than overly technical ones and I clarify some of these below, as they often appear to mean different things to different people when used in general conversation. Otherwise, all the words I have used will be understood in context and need not be defined separately.

LOCAL COLOUR

This is the basic colour of any object, for example, green grass, red roofs, brown tree trunks, a blue dress. Local colour does not in itself create excitement unless relationships are particularly interesting, nor does it create mood and atmosphere.

TONE

I use this to mean light and dark, whether applied to illumination or to colours. In terms of colour, any colour is divisible into tones of itself – for example, Prussian Blue can range from its darkest tone through a scale of successively paler blues to white.

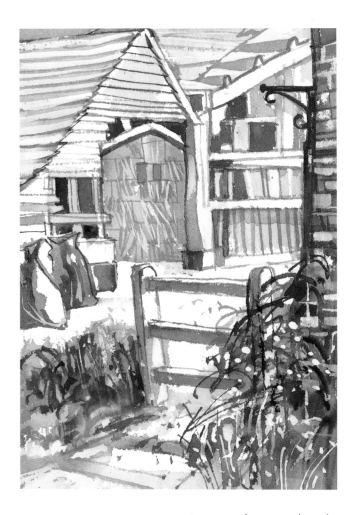

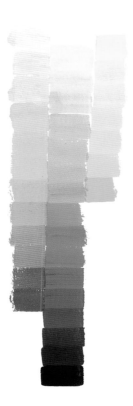

Look at these three tonal scales and notice the greater range of tones of the darkest colour. You will see that different colours can be similar in tone or quite different. There is something important to note here: there is a limit to the darkest tone of any one colour. For instance, the deepest yellow can never be as dark as a crimson and no colour can be as dark as black.

In a monochrome work, such as this painting of a barn in Prussian Blue, the scale of tones can be seen very clearly. At any given point it is possible to change a tone and rearrange the balance of the painting.

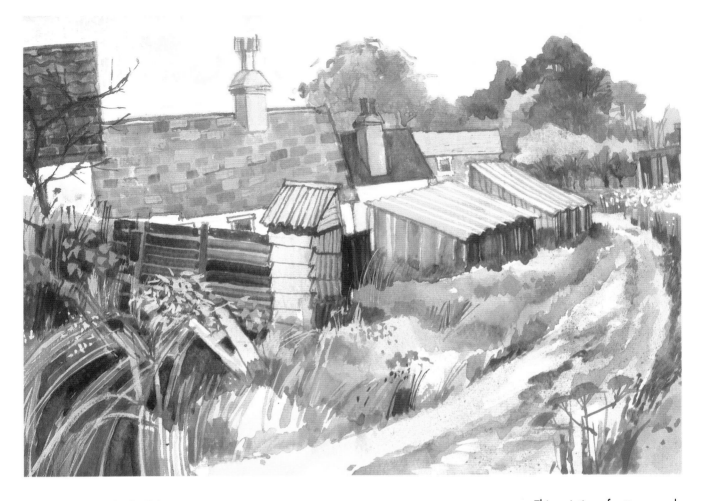

'SORTS OF COLOUR'

I might, when describing a painting, talk about 'sorts of green'. Some people say 'shades of green' when they mean all sorts of different greens – but 'shade' in some countries can be the same as 'tone'. So to avoid confusion I use 'sorts of ' to mean all kinds of greens – or reds, blues and so on.

Many people have problems in mixing a variety of any colour, but particularly greens. This may be because they tend to 'name' colours and when they run out of names, they are stuck. If you have this difficulty, go on practising mixing blues and yellows, adding minute quantities of other colours, including white, to modify the results.

This painting of cottages and a pathway was done mainly in different 'sorts of ' green. There is also a wide tonal range from darkest green to nearly white.

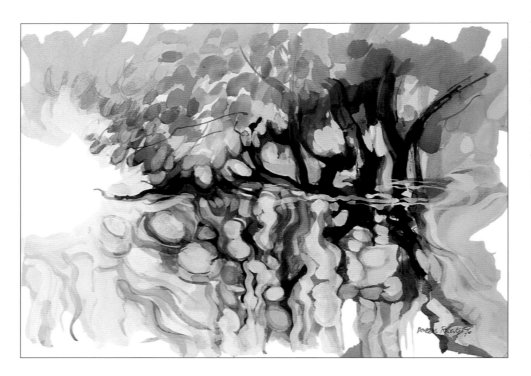

This painting of reflections is mainly 'warm' because of the predominance of orange/yellow. The designations 'cool' and 'warm' are imprecise, however: although there are oranges and browns in this painting, the general effect is fairly cool.

HOT AND COLD COLOURS

These are inaccurate terms as blues and greens, which are generally known as 'cold' colours, can also be made in 'warm' versions, and red, a so-called 'hot' colour, can have 'cold' versions. Nevertheless, the general usage of the terms can be helpful sometimes. Here are some paintings to show the differences between the terms 'hot' and 'cold'.

Although painted in so-called 'warm' colours, this painting has a deserted, cold feel. Ask yourself why this is.

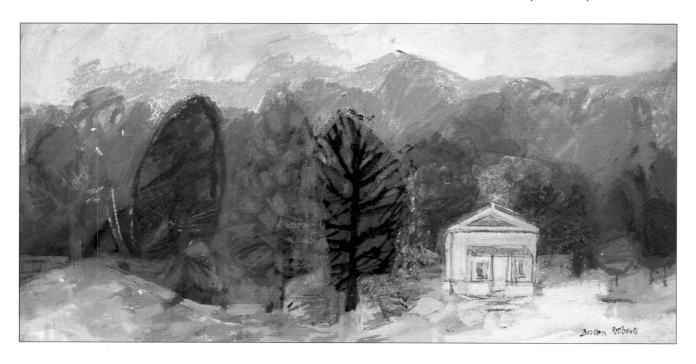

This was a small experiment to see what sort of mood could be created with strong blues dominant. Do these blues really seem 'cold'?

COLOUR FAMILIES

This is a term relating to 'sorts of ', but it is more specific. For example, the brown family can contain any sort of brown but stops short where a red-brown becomes more red than brown and a green-brown becomes more green than brown. In other words, one family stops where it begins to move into another. Sometimes the demarcation line is very subtle.

Most of the colour patches which are grouped together here belong to a family of reds, but notice how one or two are moving towards a blue family.

HARMONIES

Different colours can be made to harmonize by using one colour as a common denominator. Try adding, say, a little bit of a blue to any other colours you fancy – just enough for the colours to be comfortable with each other. If you add too many colours you will end up with 'mud', so be careful. Note that almost any amount of another colour will entirely change a yellow; for example, a minute touch of blue will turn yellow green.

EXERCISE

Paint some groups of harmonies and at least two groups of families and see the differences for yourself.

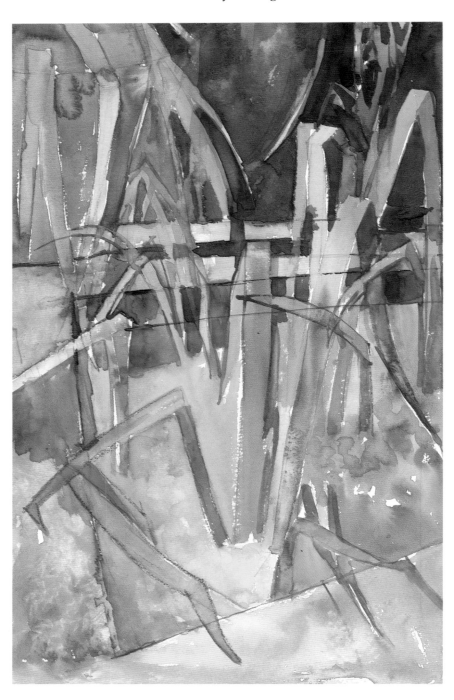

This is a colour rough for a painting, made on the spot using gouache very wetly for speed. Notice the difference between this and the 'flat-and-matt' use of gouache in the painting shown on the opposite page.

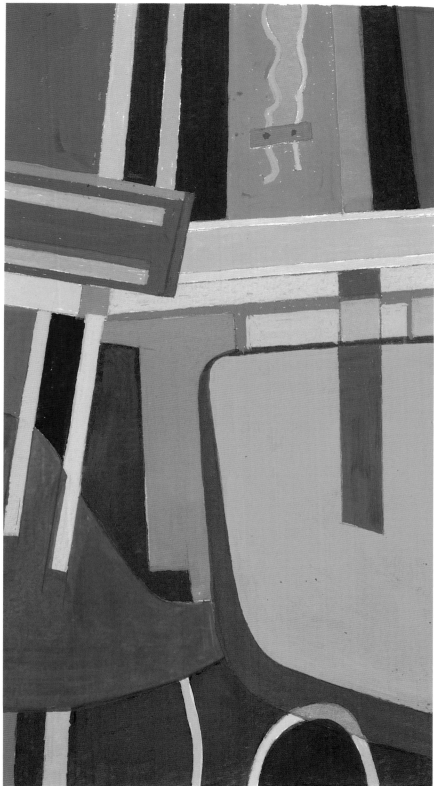

The original drawing on which the painting (*right*) is based was made in a workshop. The painting was done at home.

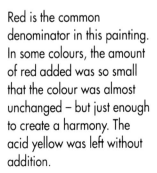

Red is the common denominator in this painting. In some colours, the amount of red added was so small that the colour was almost unchanged – but just enough to create a harmony. The acid yellow was left without addition.

Patches of complementary colours.

COMPLEMENTARY COLOURS

If you look at colours opposite each other on the outer ring of the colour circle on page 31, you will find what are called complementary colours – blue to orange, purple to yellow, red to green and the stages in between. A complementary colour can be used in small amounts on an otherwise harmonious colour scheme to create a discord or sharpness. So a painting mainly in reds and oranges could be sharpened with a touch of bright green-blue.

Here it is easy to see how the complementary colours of equal tone vibrate.

PRACTICAL TIP

Start to collect those sheets of colour patches available in paint shops for planning home decorating schemes. Cut out the small oblongs and put them into different groups in envelopes. They are useful for all sorts of colour and tonal comparisons, making it easier to see the progression from 'family' to 'family' and so on.

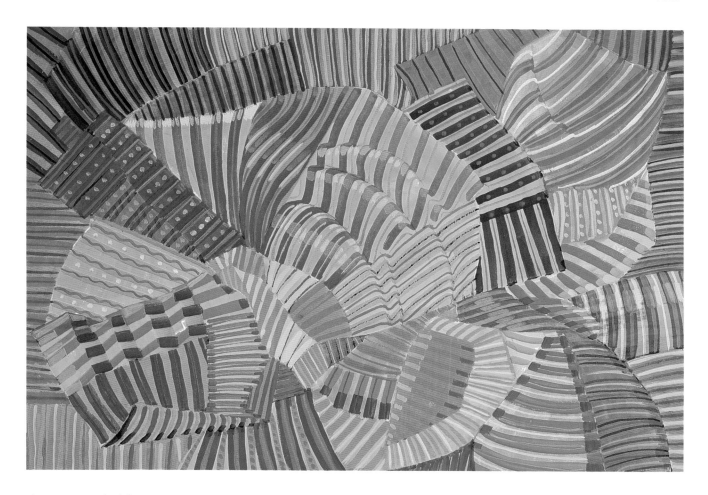

This painting, which has a strong element of pattern, was derived from drawings of the twisted ends of toffee papers. Complementary colours were used adjacent to each other to create an optical illusion of colour vibration in the original. This optical illusion normally only works when the complementary colours are of similar tones.

EXERCISE

Paint three 6 cm (2½ in) squares with very matt, even colour – choose one each of something bright like vivid pink, lime green or sky blue. Cut out and paste each one in the centre of a separate A3 sheet of white paper. Set one of the sheets against a wall and put a plain white A3 sheet near to it. Stare hard at the coloured square for about 30 seconds, then quickly transfer your gaze to the white sheet. Blink a couple of times and try to identify the colour of the after-image you see on the paper.

If you can't see it, try again until you do. I have only ever met one person who couldn't get the effect (at least after a couple of tries) if the colours were bright enough. The after-image will be the complementary of the colour you have used.

If you prefer, you could buy a small pack of brightly coloured papers for this experiment. This will save you time spent in painting the squares.

PROJECT
EXPLORING COLOUR

Before starting the project, work methodically through this chapter, making sure you have covered all the experiments and exercises mentioned within it and enlarged on them where you can. Don't skip the work because you have understood the theory! Make experiments of colour schemes, relationships, optical effects and so on, until you are as sure as possible that you can really use colour to some effect.

Now make at least five groups of colours coming under the heading *families*; five or six groups of *harmonies* with a discord; a group of colours which are all different, but are the same *tone* as each other; several separate groups of colours, each in its full scale of tones; a pair of vibrating *complementary colours*.

The arrangement of blue flowers here is purely imaginary. Both warm and cold blues have been used as foils for each other.

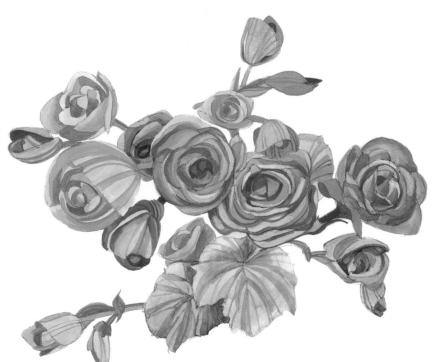

The pink and orange begonias in this painting, which was made from a pencil drawing, were arranged to make a decorative motif. These colours could also be called harmonies. Changes of tone, which create depth and form, can be clearly seen.

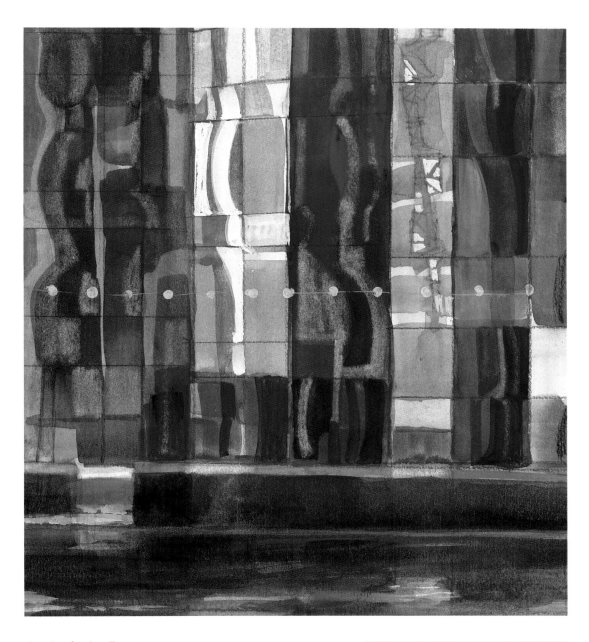

The idea for this illustration was sparked off by the construction of a modern office block. It was painted using mainly cold blues. The complementary dull yellow/orange provides relief in this almost monochromatic painting.

SELF-ASSESSMENT

✧ *Did you make sure that your swatches of colour were flat and matt?*

✧ *Did you put each colour touching the others in a group so that their relationships could be seen effectively?*

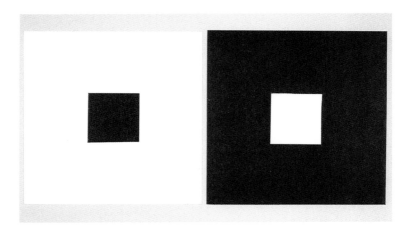

Try putting a 4 cm (1½ in) white square on a larger piece of black paper and vice versa. The small black square appears to contract, the small white square to expand.

BLACK AND WHITE

Black as a pigment is the darkest of all tones and white is the lightest, and they each create special effects when used on or next to each other. While black appears to contract, white appears to expand – in fact, the latter sometimes seems to glow. Try putting a 4 cm (1½ in) white square on a larger piece of black paper and vice versa so that you can see the result for yourself. You won't have black in your palette, but the theory is valid and useful. If you use the very darkest colour you can mix, it will create nearly as great a tonal contrast with white.

NEUTRALS

Neutrals are basically greys which have little colour bias. Neutral grey, which is made from black and white and has no colour bias, is the true neutral and more than any other will affect colours enormously.

The experiments shown on the opposite page will give you an idea of how influential greys can be, but it is very important that you make some examples for yourself. Keep trying experiments until you understand the relationship between greys/neutrals and colour. Try, too, putting coloured squares on a grey ground and compare all your results.

Some people are so intimidated by clean white paper that they tint it before they begin to work. This is not very sensible if it is all to be covered up. Fresh white is just a surface. I would advise people to be very wary of painting on a tinted surface unless they know exactly what could happen when they start to put colour on it.

Here are just a few examples of greys and neutrals. See how many more you can make.

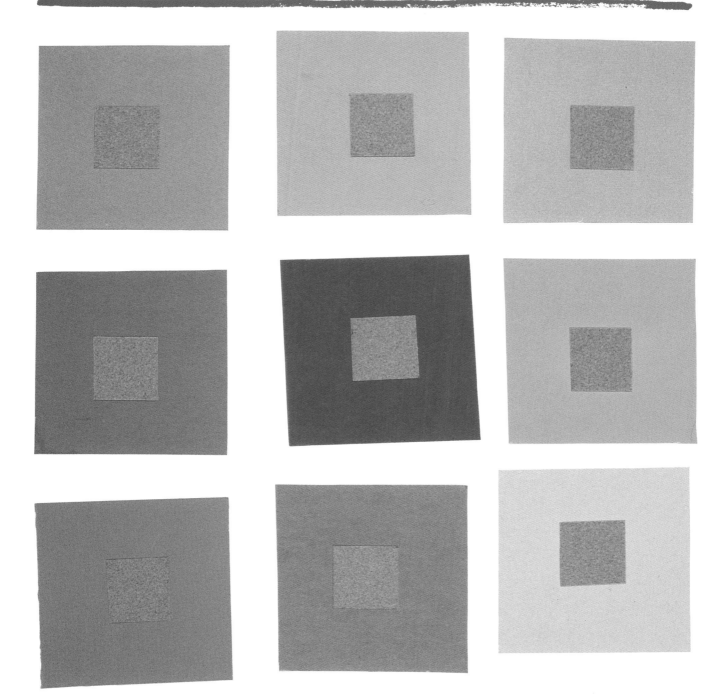

To see the relationship between greys and other colours, try this experiment. Note that all the greys were cut from the same piece of paper. Place a 3 cm (1¼ in) grey square of paper in the centre of an 8 cm (3¼ in) bright red square. Then compare the effect of the same grey placed on a blue,

a yellow or a green square. What happens to the appearance of the grey? Does the tone seem to change? Does the grey seem actually to change its greyness?

EXERCISE

Make at least six groups of colours which might be used to suggest different moods or atmospheric conditions. Give these moods a name before you start – don't make your title fit what you have done! There will be more about this in the next chapter but it is a good idea to try something on your own first.

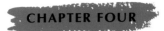

TONE AND COLOUR

I have already defined 'tone' and explained it in theory in the previous chapter, but how does it work in practice? It would have been less difficult to explain when everyone had black-and-white television sets and could take in one tonal scene at a glance; now, we are so used to seeing everything in colour that we notice each separate local colour – for example, that car is red, that woman is wearing a blue dress – rather than the relationships between one colour and another. It is these relationships, where colour must also be treated as tone, which can lift a painting from the basic 'copying' of what we see to one that can move us to appreciation of more than just technical merit.

Doreen Roberts, *Net Sheds*, 35.5 x 25.5 cm (14 x 10 in), gouache. I was more interested in the patterns and shapes of the sheds and the texture of the nets than in 'reality'.

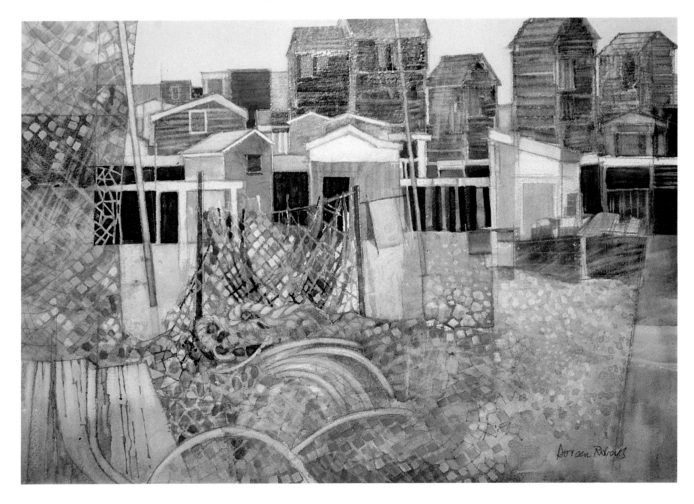

The local colour in this
illustration is uninteresting
and the tones too similar and
dark, so that the whole
picture is unbalanced.

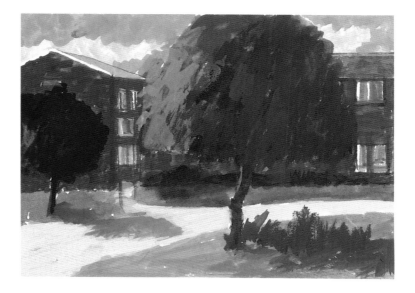

Although the colour in this
painting is still 'local', the
variation of tones creates
greater vitality.

Here the changes in both
colour and tone create an
entirely new mood. Any
painting can be
reinterpreted in this way.

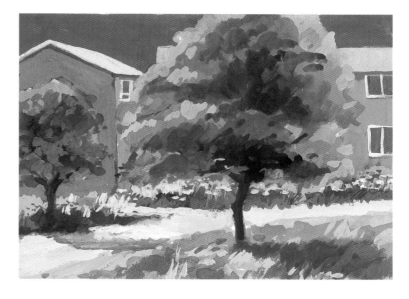

TONE AS COLOUR

Look at the two small abstract paintings on this page. Both have a number of colours, but in one there is an enormous tonal contrast, and in the other hardly any contrast at all, except for one small accent. Which do you think creates the greatest drama? Which the least?

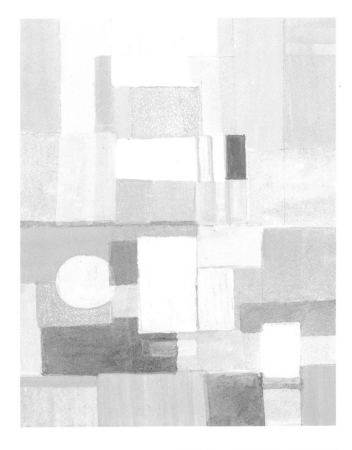

In this abstract the tones are mostly very close together and mainly light, except for a few mid-tones and one small dark point.

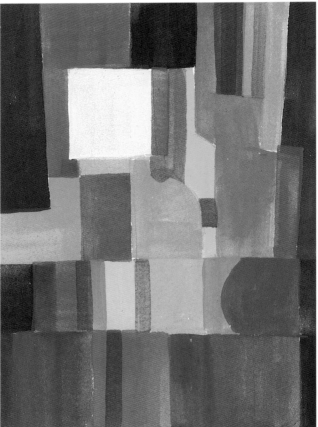

The colours in this small abstract painting are mainly warm and dark, except for a main patch which is very light in contrast. Does this, in fact, suggest light?

TONE AS ILLUMINATION

The two paintings on this page follow the pattern of the two shown opposite in terms of tonal contrasts. But here the contrasts have been used in a different way to show subject matter, to create light effects and to focus the eye.

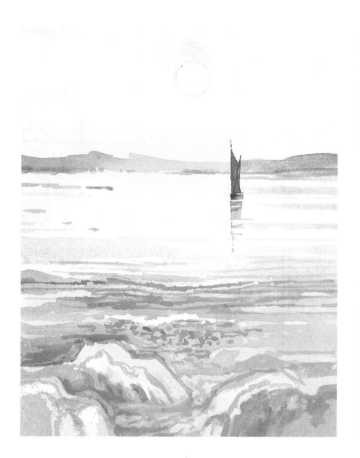

This interpretation of the abstract opposite is freer in its use of the tonal pattern. Here the soft light of morning over the sea contrasts with the small dark sail of the barge. Too much contrast or too many, however, could have destroyed the mood.

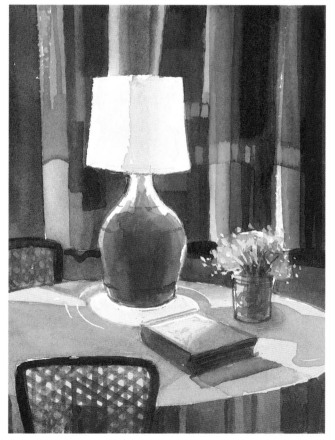

The still life here is an interpretation of the tonal arrangement opposite. It is easy to make the light source clear when the area is shown as a table lamp.

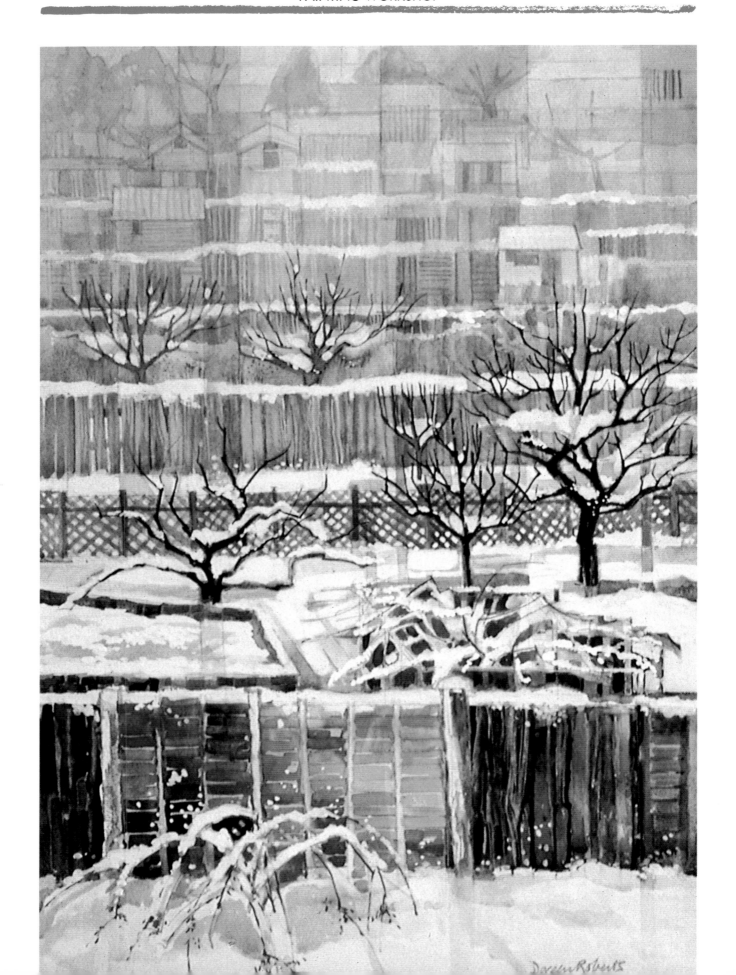

TONE AND MOOD/ATMOSPHERE

Mood and atmosphere are not just shown through colour but through tone. After all, if most of the colours in the painting opposite of gardens in the snow were not light in tone, then it would not convey the impression of light mist but take on a quite different atmosphere. So think *tone* and learn how to use it; then your paintings will acquire more life and vitality as well as showing more varied effects.

Start straight away to develop your powers of observation and visual memory. Look out of your windows over a period of a month and write down all the colours and tones of the weather and of the different times of day you can see. Don't just give commercial names to the colours, but create your own personal descriptions of them.

It doesn't matter whether you can see beautiful countryside, run-down old factories, high-rise flats or whatever; the weather and time

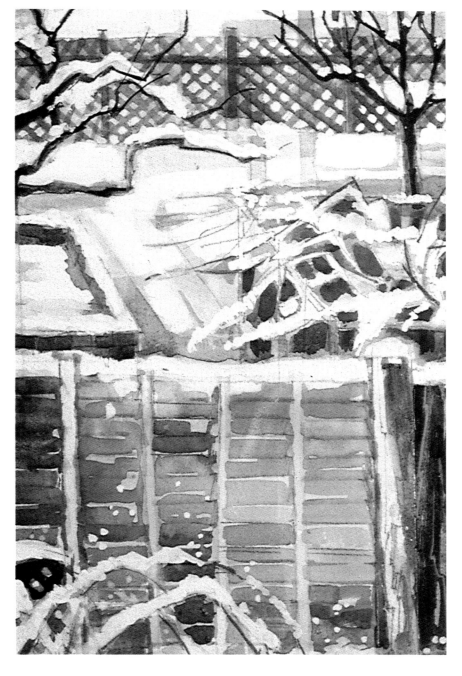

◀ Doreen Roberts,
*Gardens
in the Snow,*
46 x 30.5 cm
(18 x 12 in),
gouache.
In summer this
view from my
window is loaded
with heavy
greens, but when
the trees are bare
and there is a
light coating of
snow, the pattern
of gardens is
more interesting –
and with the early
morning mist the
scene becomes
even more
atmospheric.

▶ Detail from
*Gardens in the
Snow.*

49

of day will affect all of these and you will be able to see the effect on the reds of bricks or the neutrals of pavements just as much as you can on the greens and browns of the countryside. Learn through whatever is available, regardless of whether you like it or not, so that you will have plenty of knowledge when you come to paint your chosen subject. It is also a good idea to make small trial paintings whenever you can.

Look carefully at skies, wherever you are, and notice the time of day and the type of weather that accompany them – they are great indicators. Try to paint them if you can, this time using your paint more thinly so that colours mingle quickly. Alter or add with thicker paint. Don't worry if your work looks awful at this stage; doing it is important and you don't need to show anyone until you wish to.

Here are two interpretations of the sky, using either basically greens or browns. The important thing to remember when creating a dramatic sky is that the tonal changes must be clearly observed.

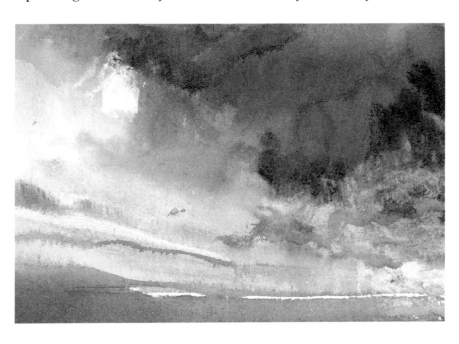

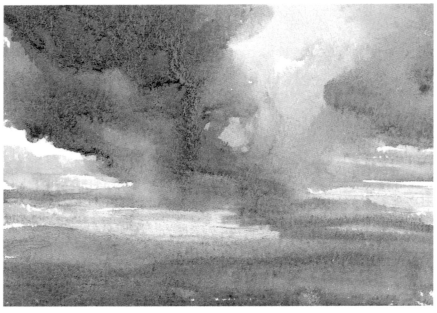

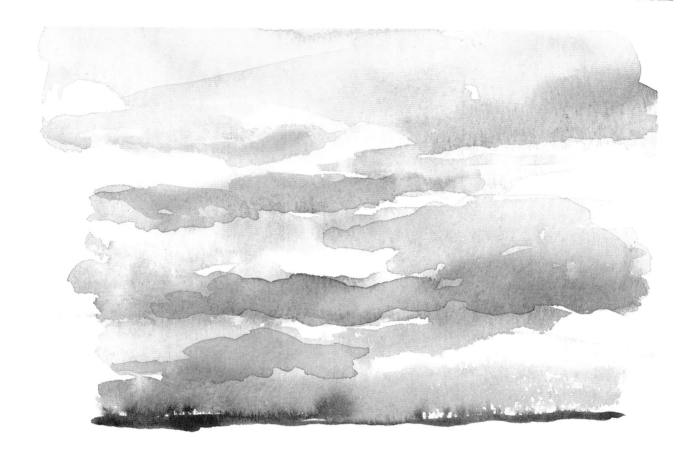

Although the cloud formation in these two examples is similar, the paint has been used very differently. In the lowering sky the paint has been used thinly, almost like watercolour, whereas in the blue, sunny sky the colour is more opaque. This shows the versatility of gouache clearly.

TONE AND TEXTURE

In your very first experiments in Chapter 2: Using Paint, you made a lot of textures with paint, but these were not related to tone in any particular way. Try a few experiments where the same textured areas you invented get lighter and lighter while using the same colours and the same tool marks. You can do this either by making all the colours lighter as you work or by spacing the tool marks farther and farther apart. Try both methods so that you can see how to use your paint and tools successfully.

This brickwork texture is graduated from dark to light by making the paint colour paler.

The spiky texture here is changed gradually from light to dark tones by spacing the brush strokes closer together.

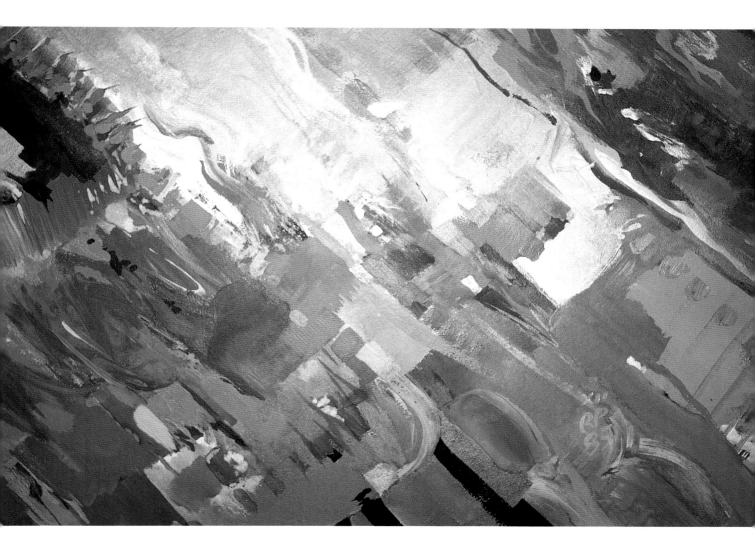

Richard Plincke,
Full Orchestra,
51.5 x 75 cm (20$\frac{1}{4}$ x 29$\frac{1}{2}$ in),
acrylic

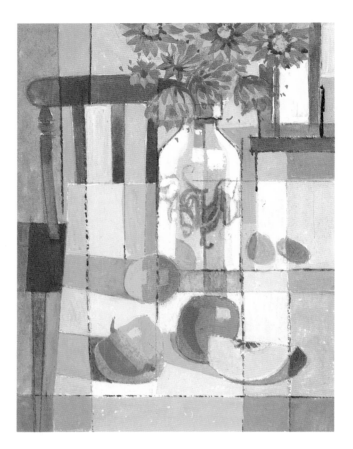

Not only the background but also other props have been integrated into this painting in such a way that the still life seems flat and the table and chair to stand on end. The illusion of form has been minimized to create a more abstract feel.

TONE AND STILL LIFE

One of the most useful subjects for practising tonal relationships is still life. This is because groups of objects don't move of their own volition, but can be affected by light – and this can be 'manufactured' by using tone and colour imaginatively and not necessarily realistically. Mood and atmosphere can in this way also be created by you.

Objects may be seen as light against dark and vice versa, and rich tonal patterns can be created in just the way you want. Remember that backgrounds, too, which are often seen as something separate from a group of objects, naturally form part of the relationship and are an integral aspect of the whole.

When you have a few moments to spare, get into the habit of looking at the surroundings of any object in your room. Try drawing those surroundings first as if the object were transparent, then draw the object on top. Draw just shapes, no details.

EXERCISE

If there is a programme on television which does not interest you, turn the sound off (or ignore it, if someone else is watching) and just look at what is behind the action – for instance, behind people talking. Make quick drawn or written notes about the tones of the surroundings or just study them closely.

TONE, COLOUR AND FORM

We see objects in three dimensions and we refer to this quality as 'form'. Representing 'form' is a perennial problem in painting. Of course, it isn't always necessary to show solid form. Could forms be painted as flat shapes? Try looking at the more decorative works of Henri Matisse, for example.

How would you deal with a still life without showing form? Does everything have to look exactly the way you see it or could it be changed in some way? If you take this approach to any

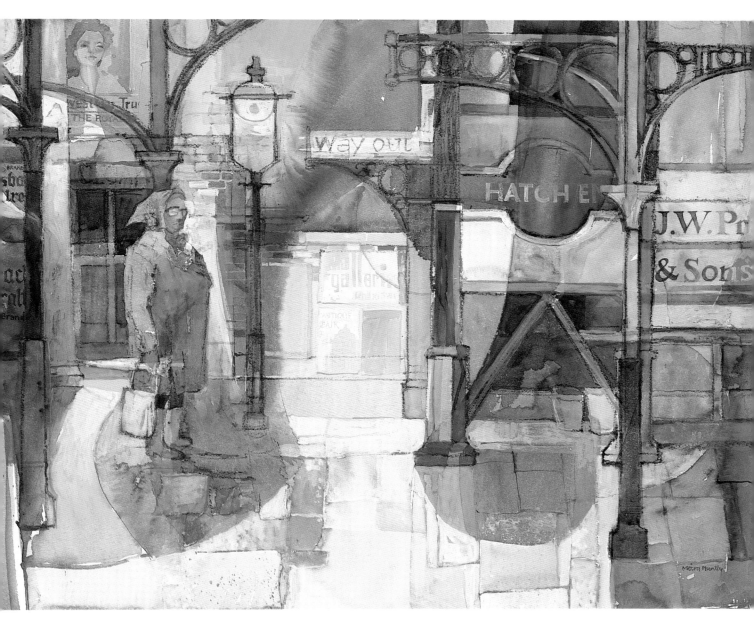

subject, you will begin to see the possibilities that are open to you.

Look back to your work in tone and colour and try putting some patches of tones of colours together in such a way that some seem farther away than others. This will help to create distance in terms of flat space. If you wish to create three-dimensional effects, then graduations from light to dark need to be made.

Moira Huntly,
Underground Station,
56 x 73.5 cm (22 x 29 in),
watercolour and gouache.
This is a complicated subject more usually treated in a three-dimensional way, but here the design quality of the architectural elements has been accentuated to integrate the whole by flattening the space. Colour, shape and tone have also been used to reinforce this and to create mood. The colour has been limited to enhance this spatial aspect and to create some ambiguity.

PROJECT
EXPLORING MOOD

As an extension of your experiments, play some music with which you are unfamiliar and paint shapes and textures – not recognizable images – in colours and tones that the music suggests to you. This will be fun; it isn't great art any more than your playing with paint was, but it is a great way to experiment with painting a feeling, a mood or an atmosphere. Get your paints ready before you listen, and play the music at least once before you start to paint so that you know what colours to mix quickly.

Some of the earlier exercises were intended to help you develop your handling of paint in relationship to landscape ideas. This one is a less random experiment and should help you to manipulate paint in relation to mood and your personal reaction to sound.

It may be worth considering that, like music, colour can vibrate and 'sing' and almost create a sense of movement in itself. Never torture your paint in your efforts to use it in an unfamiliar way.

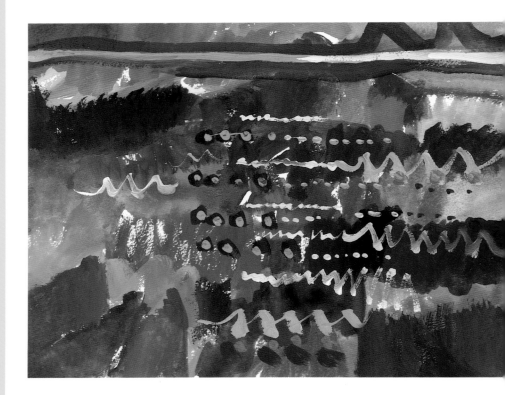

▲ This is my painted interpretation of Aaron Copland's 'Billy the Kid', which I played to a group of leisure painters. We listened to the music together.

Although I knew what was being played, I made sure that I responded only to the music, so that the gun battle was represented by marks rather than images.

A painting by Stella Hunt, done to the music of Prokofiev's 'Lieutenant Kije Suite'. This was the first attempt by one of the group at using paint in this way.

She had not heard the music before and so she interpreted it in her own way, using heavy, dark tones and 'thundery' colours.

I did this painting to James Galway's 'Songs of the Sea Shore and Other Japanese Love Melodies'. The mood of these pieces of music is gentle and lyrical – the flute has a clear but plaintive sound which affects one's response to colour and to the marks put down. The mood of this painting would have been destroyed if darker tones and more aggressive colours had been used.

SELF-ASSESSMENT

✧ *Did you cheat and play music which you had heard accompanying a visual performance such as an opera or ballet, for example?*

✧ *Did you respond instinctively to the sound only, or did you allow the title or any prior knowledge of the music to influence you?*

✧ *Did you try to paint images which were too specific or did you create new and unexpected marks and colours?*

✧ *Did you have all your colours set out ready and did you use them freely to interpret the rhythm and sound?*

Strong, active tool marks have been used here to convey 'Anger'.

IMAGINATIVE MOOD

Many people panic at the thought of using their imagination in a painting, but this is usually because they see the activity as a frightening 'out of nowhere' situation. But it doesn't have to be like this. Try something that is often done in

schools and which I have found useful for all age groups and abilities.

Work out some colour swatches to represent different moods, like Anger and so on, and see what happens. Here are a few ideas: Peace; Rushing; Speed; Calm; Agony. Add more of your own and try to be fresh in your response.

To create a mood of 'Calm', smooth, gently undulating brush strokes are appropriate.

Different types of jagged, violent marks such as these could create a variety of moods.

Don't do the conventional thing because you have been conditioned to think that certain colours are 'typical'. Try to be positive about the colours you would use if you had never thought about it before.

STYLE AND MOOD

From all the experiments in this chapter you will probably have realized that not only tone, texture and colour help to create a 'feel' in a painting, but the way you use your tools to further your ends is very important. Making marks and using the tactile qualities of paint in order to put over what you are trying to convey are of prime importance. If the paint is overworked and 'dead' it will not be inviting to look at, nor will it convey the right mood if the marks you make are not appropriate.

EXERCISES

1 Mix up a family of reds containing a variety of tones. Instead of putting colour patches in a group, put them in a row, one touching the next. Now mix a family of greens and try to match the tones in the red family. Put each matched tone under and touching the one it equals.

2 Take some darks from one family and some lights from another and arrange them together within a rectangle so that the arrangement of both colours and tones is comfortable.

3 Make some small abstract paintings using textures to suggest: Storm; Dawn; Mystery. Don't use recognizable images or try to create scenes.

4 Initiate a series of experiments of your own based on tone, colour, texture, tool marks.

LOOKING FOR IDEAS

Peter Folkes, *Striped Landscape near Winchester*, 38 x 56 cm (15 x 22 in), watercolour. Although this is a 'realistic' landscape, it has a very strong sense of design, especially in the stripes of the fields.

When you want to paint or think you might want to learn, what do you consider as possible subjects? No one has yet said to me anything like 'I'm fascinated by old metal' or 'I love the way shadows make strange patterns'. In fact, I have found that most adults either have no idea at all, or they slot themselves into three main areas – landscape, portraits or still life – and want to paint in watercolour or oils.

All this is restricting and is based on our education from the works of the Old Masters and our conditioning to expect 'reality' and 'scenes' in paintings. In this century we have many different stimuli and a greater variety of subjects within our reach. We also have a wider, more accessible range of tools and materials. If you really want to paint, you will need to develop an active interest in your environment.

▶ Doreen Roberts, *Fishing Floats*, 35 x 45 cm (14 x 18 in), gouache, watercolour crayons, graphite pencils. Sometimes a small area is as interesting to paint as a whole scene.

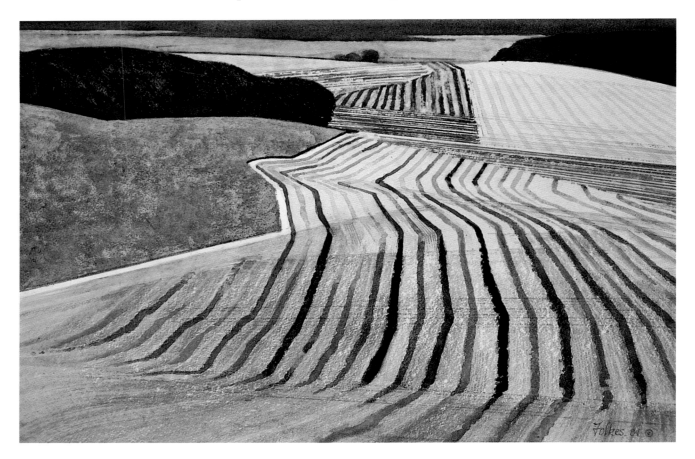

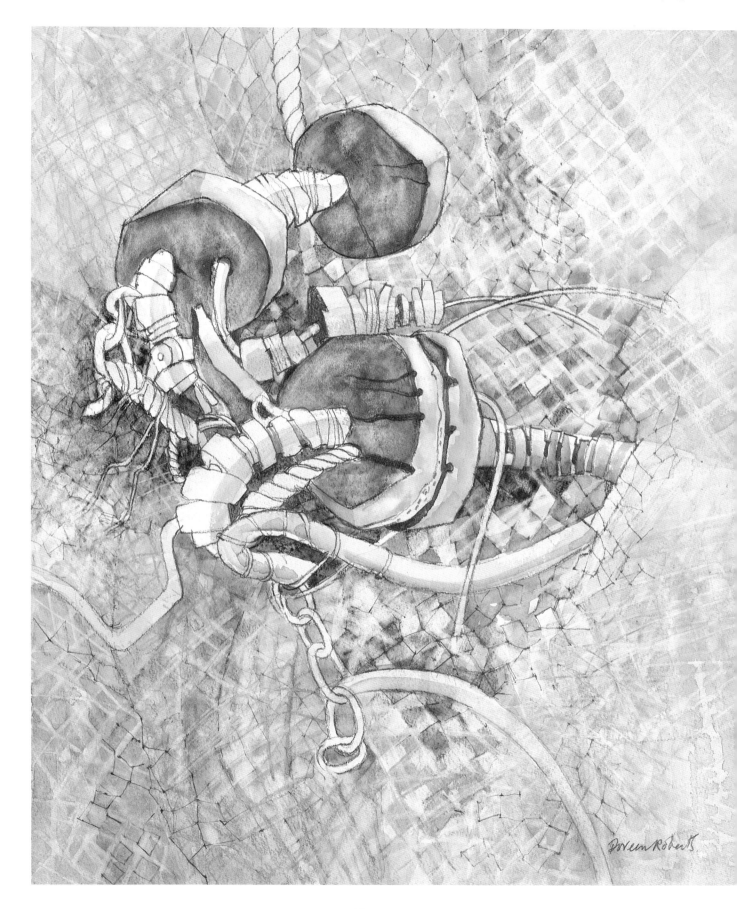

Susan Pendered,
*Towards
Sundown*,
54.5 x 35.5 cm
(21 ½ x 14 in),
watercolour

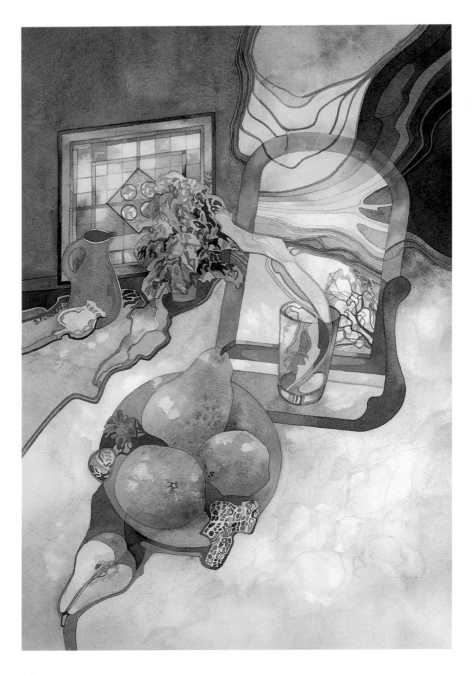

PERSONAL ATTITUDES

Ten artists of equal technical ability could paint the same subject, yet each would emphasize a different aspect. The three paintings here all feature a still life, but see how different they are despite the similarity of the subjects. The differences show in the use of colour, in the way in which the objects relate to each other, and in the very personal style of each artist.

Go to some really good, professional modern shows. You may not like all you see, but it can enlarge your horizons and change your perception of painting. The world really is our oyster; at least, the world we can reach in our daily lives, in our work or on holidays.

View paintings with a fresh eye. Look at the marks made by the artists, and think about how they deal with colour and all the other elements of painting to put over their ideas. Notice the scale of marks to overall size, and how the format is chosen according to the subject. Art is a language to be learnt; never dismiss a painting because you don't understand it.

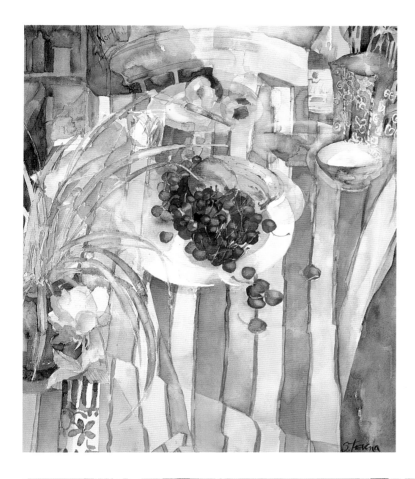

Shirley Trevena,
*Cherries on a
White Plate*,
55 x 48 cm
(21$\frac{1}{2}$ x 19 in),
watercolour and
gouache

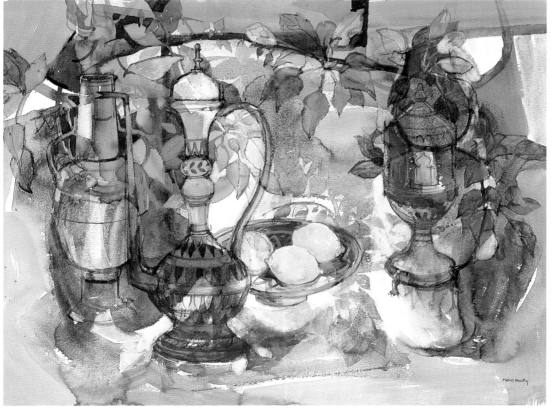

Moira Huntly,
*Moroccan Pots
with Lemons*,
56 x 74 cm
(22 x 29$\frac{1}{2}$ in),
watercolour

Doreen Roberts,
Old Pier,
35.5 x 45.5 cm (14 x 18 in),
gouache.
Here I wanted to show the contrast between the rusty supports on the land and the silvery shapes of the main pier. Light tones, similar to those in the early morning sky, have been used to 'push back' the main part of the pier and darker ones to create a shadowed area underneath it. The rusty area, of course, comes forward as it is darker and also bigger.

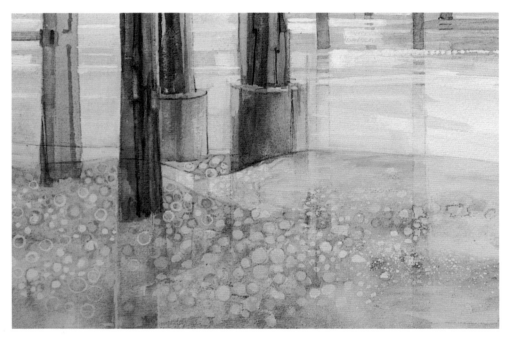

Here is a detail of the treatment of the shingle in *Old Pier* – I had to devise a way of showing pebbles without painting each one. This is the sort of problem which is often solved by experimenting – and everyone will have a different solution.

When you choose a possible subject, consider exactly why you want to paint it. It is not enough to say 'I like it'; you must work out why and what interests you most about it. If you want to be a painter of any quality, remember that most people can learn how to use paint efficiently, but how many extend this ability beyond producing boringly efficient work which others of less skill may admire? If you have a favourite subject in general, pursue it in particular. Depending on your starting point, paint it big or small; emphasize detail and not the whole or vice versa; paint it flat; move in close and leave some of it out – in other words,

This is a colour rough made from a pencil sketch of a local garden done on the spot. I made written notes about colour and tone on my original pencil sketch. The finished painting, *Japanese Garden*, is illustrated on page 81.

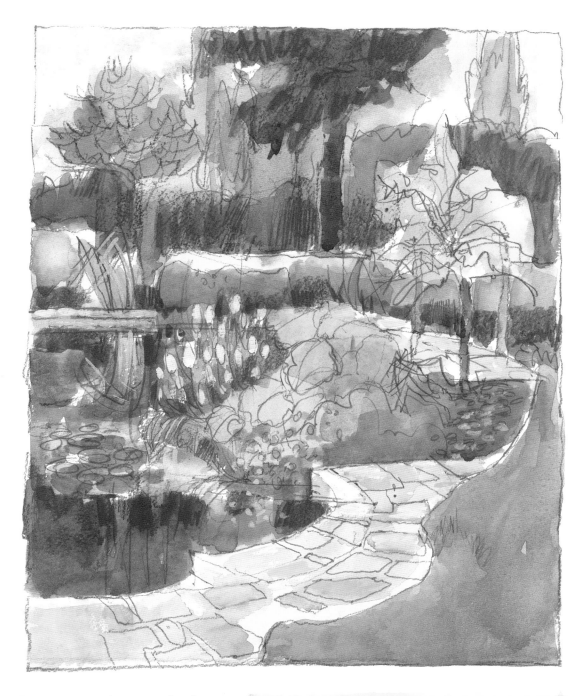

explore it and gather your passion to make the work yours. Skill will come with practice; having something to say with your skill comes from attitudes and emphases. Write down your thoughts and feelings about your subject to help you clarify your intentions.

If you are a true beginner and don't feel ready to make serious paintings yet, don't worry. Just read on and return to these experiments when you're ready – but meanwhile, keep a sketchbook of drawings and written notes.

PRACTICAL TIP

Carry with you in your sketchbook a very small pair of L-shapes which you can adjust to help you see your subject in various ways. Don't forget that paintings can be short and fat or long and skinny – there's no rule, just make the proportion right for what you want to say.

SKETCHBOOKS/NOTEBOOKS

Manufacturers often print 'Sketchbook' on their pads. A sketch, by dictionary definition, is 'a rough drawing representing the chief features of an object or scene', and the word 'sketchy' means incomplete. The so-called sketches of the Old Masters, nevertheless, are often a delight and so complete that the term 'sketch' is totally inaccurate to describe them; by contrast, those of the inexperienced artist are more likely to be 'sketchy' and of little use for future work, although they are enjoyable to do.

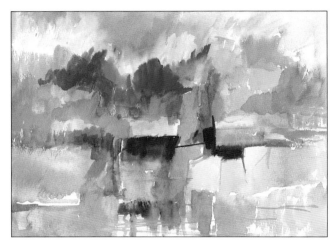

▲ This pencil sketch (top) was made crossing the spine of a notebook. The colour version in gouache was a rough idea for a colour interpretation. This is an idea still waiting to happen.

▲ This sketch was made with a fountain pen and some colour wash. When the latter was added, the pen ink ran – no problem in a quick note.

► The flowers and ivy leaves were just a rough idea jotted down from life in pencil and pastel.

The sketch of sea and gull (above) was a rough idea from memory of drawings done years previously. It was made in pastel for speed. The cliffs (left) were sketched on the spot with pencil and watercolour.

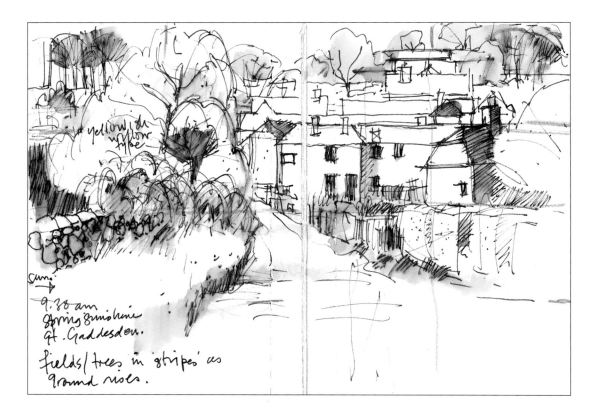

Within the sketch (handwritten notes):
yellow + sh yellow type

sun.
9.30 am
spring sunshine
Gt. Gaddesden.

fields/trees in 'stripes' as
ground rises.

This sketch is very rough, but it is of an area which I see fairly frequently and, by the time I drew it, I knew exactly what interested me most. It provided the basis for the painting opposite.

A trained visual memory can fill in the gaps in a sketch, but if yours is not yet well-trained, then you need more information drawings as well as copious notes and details if you are to work, say, a summer landscape in the quiet warmth of your own home in winter. So, personally, I prefer the word 'notebook' or even 'ideas book' as these terms describe the function of such a book more accurately. However, the term 'sketchbook' is widely used and the title doesn't really matter as long as the true function of the book is clearly understood.

Sketchbooks are very revealing and personal, and a good one can be exciting and show the potential of both artist and student. Draw anything and everything, and collect interesting cuttings from magazines – not just whole pictures but snippets of colours, textures and so on – as well as real bits and pieces. Put in your sketchbook anything visual which excites you. It is a good idea to look over old sketchbooks to see how your interests develop and change over a period of time, and this may well provide you with new ideas.

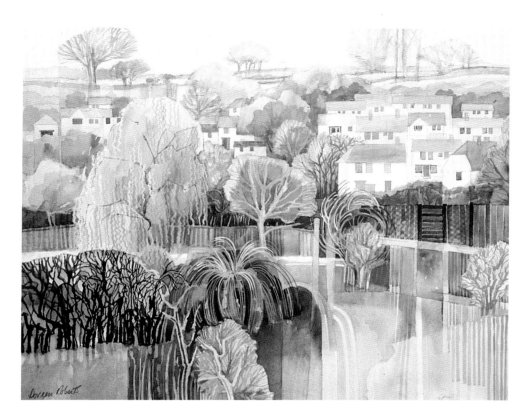

▲ Doreen Roberts,
The Village,
35.5 x 46 cm (14 x 18 in),
gouache.
As I was in my car when I
made the sketch, the road
could be seen running
straight into the centre. I
ignored this and concentrated
on the bramble hedge, the
willow and the group of
houses, using colour as
design rather than as local
colour – although it is related
to the latter.

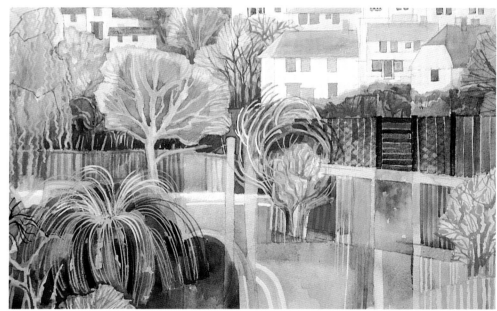

Detail from *The Village*.

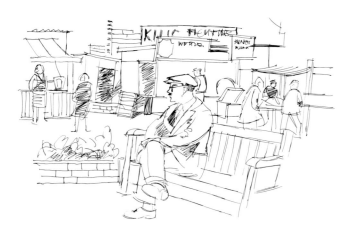

This pen drawing of a man on a bench was done on the spot. In a public place it can sometimes be difficult to draw much detail.

GOOD FOUNDATIONS

So can you draw efficiently? No? Well, let's look at the importance of drawing and the misconceptions there are about it.

Drawing is not just about using a pencil (although pencils are delicious tools) or about making an efficient 'copy' of something in front of you. One can draw with a brush, chalk, a twig – with anything capable of making marks. A drawing can be linear or it could be made entirely with dots; it can be open or very solid.

Drawing is really about construction (or structure, as it is called) – of a figure, a house, a tree or whatever, whether it is from things seen or remembered, from your own notes or entirely from your imagination. In good painting, the understanding of structure is implied, so that your house, person, landscape can be convincing, whether it is 'realistic' or not.

So draw! Anything and everything. Try all sorts of ways of making drawings and use all sorts of media.

Although the brickwork and graffiti are not detailed in this sketch of an old warehouse, there is enough information here to work on.

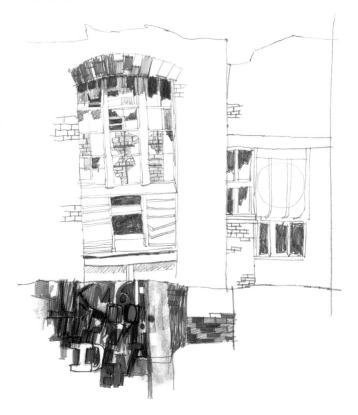

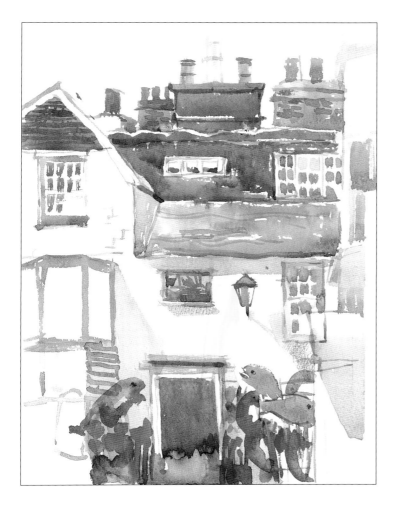

This sketch was
made on the spot
using a portable
watercolour box.
I always enjoy
painting
chimneys.

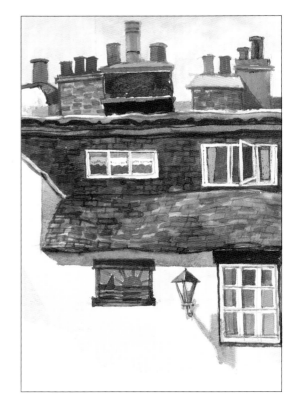

A small painting
made at home to
try a 'tight'
decorative
interpretation of
the previous
sketch, with more
emphasis given to
the windows.

LOOKING FOR IDEAS

A good teacher will know how to encourage you to 'do your own thing' as it is often expressed. Never accept the copying of photographs, even your own, or postcards or other people's work as a way of making a painting. There is a theory that this method 'starts people off and captures their interest'. It may well do that, but I have found that it is very difficult to discard such crutches, and it doesn't help anyone to learn to find their own ideas. You should try to identify your personal visual passions.

If you are learning to paint on your own or have a poor teacher, here is a useful way to start. Take your sketchbook and small L-shapes (see Exercise on page 79) and go for a walk around your area, really looking at it with fresh eyes. Pick a day with some atmosphere if you can, rather than a flat, grey day. Try to see it not as the place where you work or do the shopping or live, but as a place containing shapes, colours and textures that you might not have noticed before. Look at things like bollards, the strange shapes of shadows or the way people relate to each other in shape, colour and gesture.

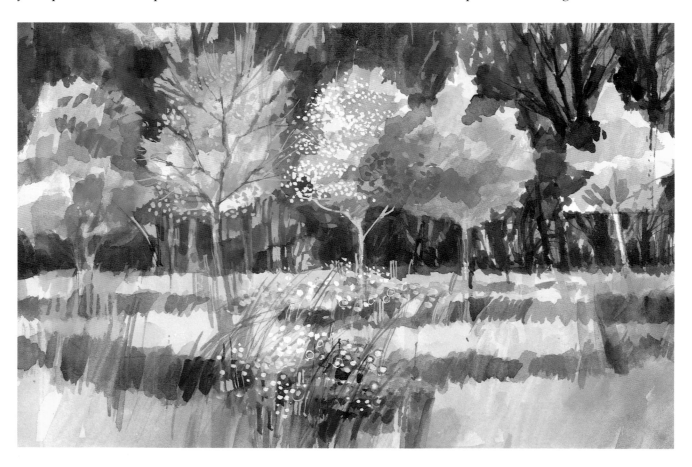

This sketch was painted at home from a very quick note done on the spot. It may never be made into a serious painting, but there is enough information if needed. I was attracted by the decorative line made by the different-coloured trees.

EXERCISE

Take one of these words – Circles, Pathways, Reflections – and when you are exploring your environment, weave this theme into your searches, looking out for anything relevant.

Ronald Jesty,
The Millpond at Sturminster Newton,
43 x 25.5 cm (17 x 10 in),
watercolour.
Instead of painting a general view, the artist has concentrated on an interesting part of the millpond which many people would ignore.

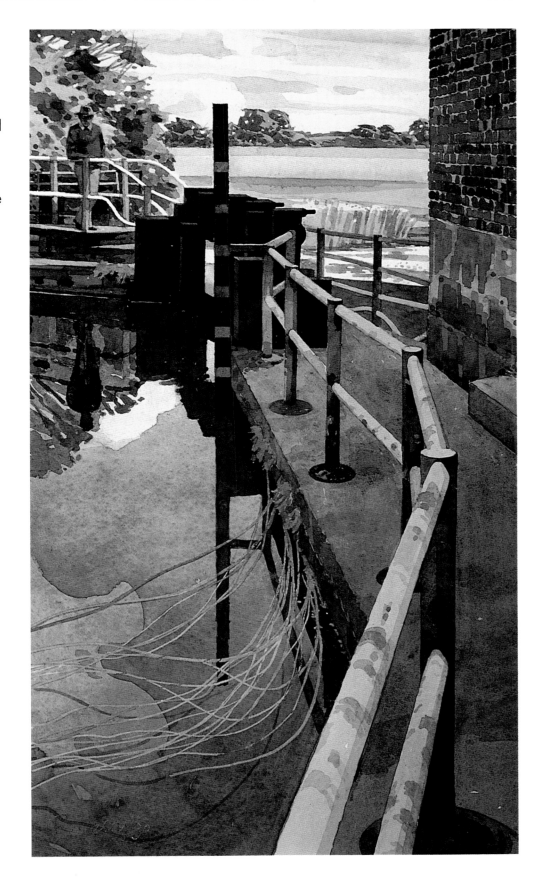

▼ Working study drawing of strawberry leaves for the painting opposite.

▲ Colour working drawings of strawberries for the painting opposite.

MAKING NOTES

If you can't draw everything you see which pleases you, do what you can and make written notes about *anything* that catches your eye. If you do this a lot, you will find that certain aspects will start to interest you and then you can begin to develop these. It may be stripes or shadows or reflections in shop windows, people in cafés, trees against buildings, farm machinery, old gates and fences, beach debris, old cans – in other words, take a 'theme' and work around it. Try using different tools with your paint, painting small details, trying various ways of showing the same thing, changing the colour, and so on.

Colour rough for the finished work with a doily fairly dominant in the composition.

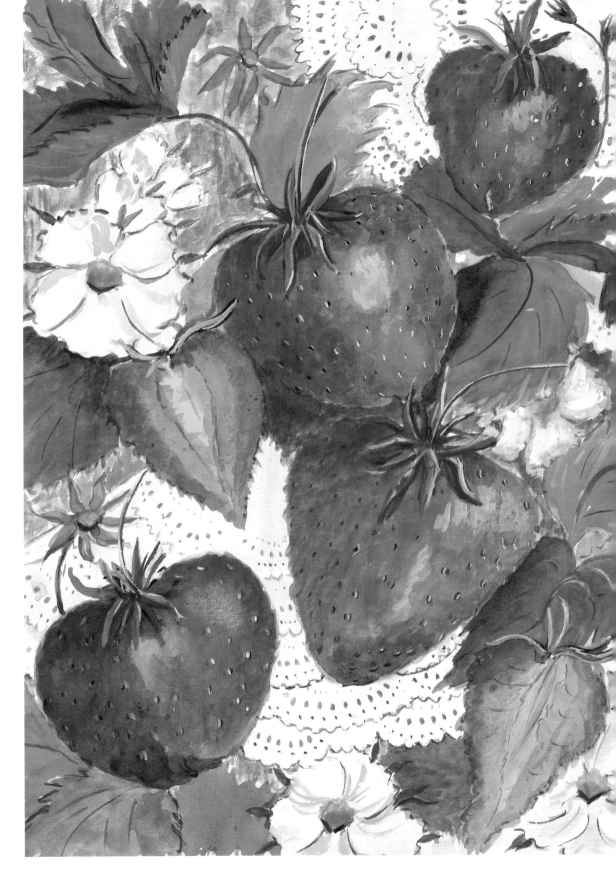

Finished work by
Stella Hunt
(leisure painter)
for a project set
on the theme of
'Food'. Here the
doily forms only
part of the setting,
so that the food
becomes more
important.

PROJECT
DISCOVERING A SUBJECT

Take as your subject part of whatever is to hand, even if you think it is ordinary. Untidy corners of rooms, open cupboards or even piles of junk can be very useful for practising your painting skills – especially if there is a strong element of shape, texture, colour or light to add interest.

If a corner of a room is too much for you to tackle yet, then take some objects which can be put together in interesting ways. Look around your home, your garden, your shed and find a group of tools, kitchen utensils, household paint-cans and brushes, plant pots, a handful of toffees, jewellery, the contents of a handbag or pocket. Use your sense of curiosity rather than your likes and dislikes to find a subject and make a painting of it.

When you have made one painting, do a second and a third – as many as you can – of the same group of objects, treating it in a different way each time. Once you begin investigating your subject in depth, you'll be surprised where it leads you.

Dorothy Day,
Corners,
gouache.
The project was set to a group of leisure painters and was the first of its kind made by this member. She chose children's building bricks set in front of a mirror and introduced the curves deliberately to act as a foil to the straight lines. It was difficult to find suitable curved objects which would be appropriate to her intentions, but this subtlety was necessary. If you meet this sort of problem yourself, take a new look at your surroundings and see if there is anything which would help.

▼ Jeanne Ramsay,
Wheels,
gouache.
The project set was 'Wheels', 'Rings' or 'Cups and Saucers'. This leisure painter drew as many steering wheels as she could and studied the tyre patterns of her own car. These were combined, using the tyre patterns as a decorative background to set off the more three-dimensional treatment of the objects.

▶ Val Beck,
Wheels,
gouache.
This leisure painter had the inside of an old clock which she found interesting and which she didn't want to dismantle. In consequence, she drew the individual cogs and turned them into a flat decorative work. The colour scheme of the painting was a personal choice.

SELF-ASSESSMENT

✦ Did you have problems in arranging things together comfortably?

✦ Did you work out exactly what interested you most in your subject before you started?

✦ Did you manage to retain the tactile quality of your paint?

✦ Did you use your new abilities to enhance your work?

MOVING ON

Our interests change quite often, or new ones develop from the old, so don't worry if several quite different subjects interest you. Just draw as much and as carefully as you can and make sure that each drawing is accompanied by written notes about light or time of day, colour and any other relevant items. When you get home, you will need all the information possible. Whether you draw people or objects, be sure to make a note of their surroundings so that you don't fall into the trap of asking 'What shall I do in the background?' Make written notes, too, on the way you felt about your subject at that particular time. Talk to yourself about your work and clarify your ideas. Once you start painting, though, forget the words and think in terms of paint alone.

After a while your sketchbook will be full, so start a new one. Don't forget that drawing and painting are ways of investigating, and there is no desperate need to 'achieve' a finished work every time. Although it may seem satisfying to think that a painting is framable, remember that if you are new to the art, then last month's success should be this month's reject. Just keep

working hard but at your own pace, and don't show your results to inquisitive people who think a week or two is long enough to equate with a life-time's work! Enjoy your progress. That is enough.

Do keep unsatisfactory work for a while (date it on the back). Some artists keep such work and all their notes and sketches, so that at some future date they can re-work a painting by approaching it in a different way. After all, if the subject matter interested you enough to make drawings at the time, it is possible that your interest will remain and just need to be revived.

This drawing looks efficient but lacks any real information. There should be details of the arch formation if structure is to be noticeable in any future painting.

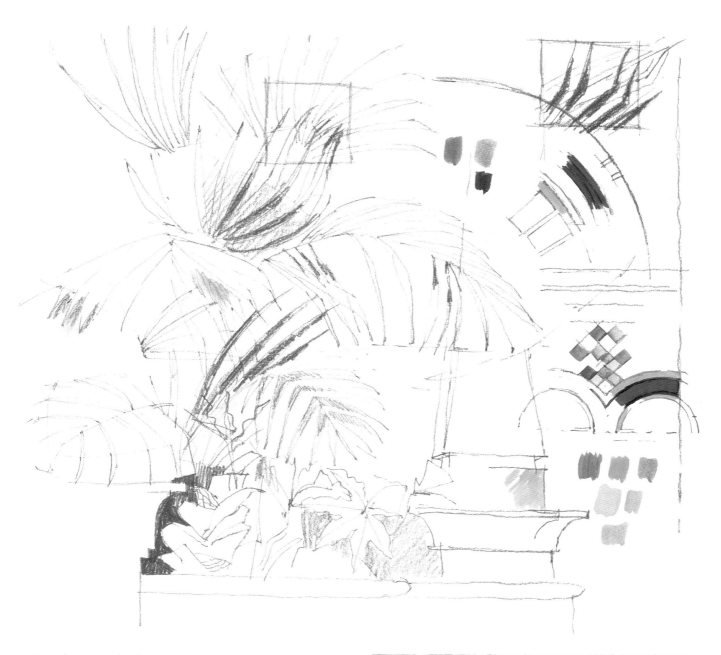

This information sketch
subsequently formed the
basis of the painting *Palm
Court* illustrated on
page 126.

EXERCISE

Our eyes take in so much from our surroundings that it
is often difficult to select ideas. Clip your smallest L-
frames together and use them a short distance away
from your face as you would a camera viewfinder. This
frame will block out the immediate surroundings of
your view so that you can assess compositional
possibilities more easily.

Try apertures of 4 x 1 cm (1½ x ⅜ in) and 3 x 2 cm
(1¼ x ¾ in) to start with and go on from there.

COMPOSITION

When you have found a subject you would like to paint, remember that you should be clear in your mind why this is before you go any further. It is all very easy to see something we like and then set out to paint it. But do we really need to paint it? Why not take a photograph or write about it – or even just enjoy it and remember what it was like. Why paint it? Well, it is only worthwhile considering painting something if you have something special to say about it that can best be told in a visual, paint-based way.

Making a painting is very specific; it is a definite choice about one's means of expression. Discuss this with yourself by asking and answering your own questions. Write down your thoughts for the first few times and continue with this practice whenever you're not clear about how to begin. Sometimes we think that we know what we want and then find we're not so sure after all. If an idea isn't coming along well, stop and clarify your intentions before you go on.

ANALYSING YOUR THOUGHTS

Here are some questions which you can adapt to suit your subject matter and which will affect the way you compose your painting:

What is the most important part (it could even be a space) of my subject? Why is it important?

Which are the most important – the shapes, the colours or the textures? How do they relate to the surroundings? How do the tones work?

What am I really trying to show in order of importance?

Is the attraction aided by mood or atmosphere created by light, weather, time or season, or simply by the formal elements of colour and texture?

▶ Doreen Roberts, *Japanese Garden*, 35.5 x 25.5 cm (14 x 10 in), gouache.
This painting was made from sketches done on the spot. Look to see where the eye is led and how it moves from one part to another.

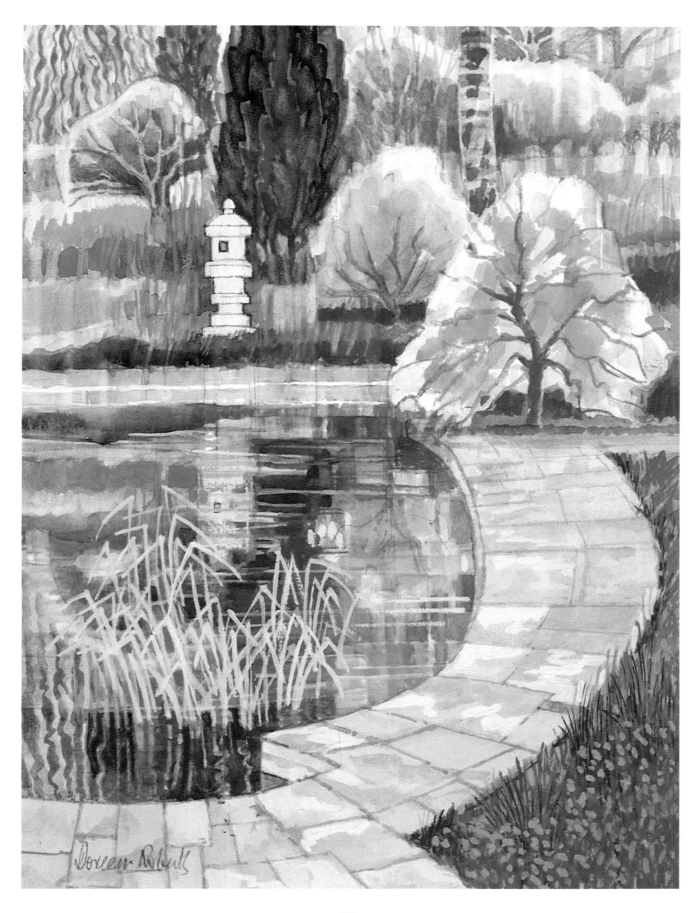

LEADING THE EYE

Composition is about arranging the various elements of a painting in such a way that the onlooker's eye is led exactly where you want it to go. In this way, it is possible to control the relative amounts of attention given to any particular part of your painting. Everyone knows how two lines converging into the distance will carry the eye to a point on the eye level (the focal point), but solutions to more subtle aims have, themselves, to be subtle. Not only single objects but groups, lines, spaces, can

With only one 'object', as here, the eye goes directly to it and remains there.

Here the eye travels between two objects without resting.

With three objects the eye moves around, but will tend to rest for longer on the most dominant.

take the eye over the painting. Look carefully at the illustrations here and overleaf: some arrangements are weak, others effective. Analyse your own drawings, too, so that you can assess the importance of composition.

Here the eye travels along the path and will focus on either the building or the tree. If you want attention to remain on only one of these, then the colour, size, placing or tone should be changed.

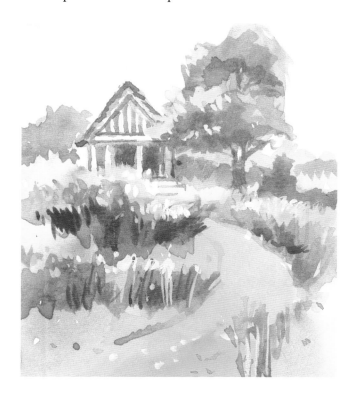

▼ Even a simple still life, such as this group of peppers, has to be set comfortably in your rectangle, so watch the spaces in between objects as well as the actual objects. If you bunch them together in the middle of your work, you will create a large area of useless space around them – and then what do you do?

EXERCISE

Arrange some everyday items such as a pile of ironing and an iron on a board, or debris left after a meal. Or try putting some of these in a group: three different fruits or vegetables; a patterned cloth; a mug or jug; a dish or basin. Another group could consist of tools with a holdall or oilcan. Look around your home for interesting shapes and forms. As you arrange them, give them space and make sure that the eye moves naturally from piece to piece, going forwards and backwards as well as from side to side.

When you have finished arranging your groups, check whether you have avoided the common traps outlined overleaf. Re-arrange your groups again until you are satisfied for the time being.

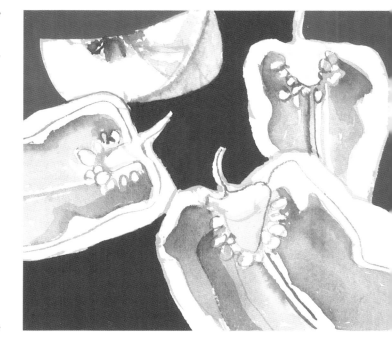

The book-end arrangement – where can your main subject go?

AVOIDING TRAPS

Try to avoid the clichés as shown in the illustrations here – the book-end arrangement, the 'something crawling up one side and along the top', and the crashes and odd corners. Things *can* be placed dead centre, or at the top or bottom and so on, breaking all the 'rules', but this is best left until you are more experienced or the subject demands it.

Looking for weaknesses in composition is easy; putting them right is not. So try to be positive – find your weaknesses, but deal with them. Don't just get discouraged.

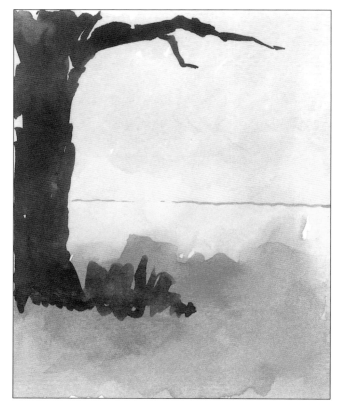

The tree looks as if it is afraid to get into the picture – it also leaves an odd-shaped space in which to place anything else in your work.

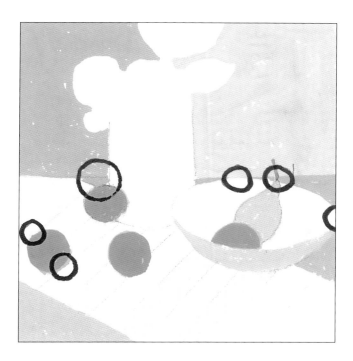

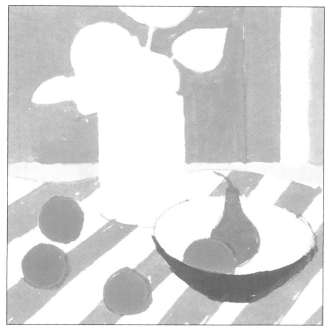

This diagram shows several 'crashes' and meeting points where objects and lines converge uncomfortably. An isolated diagonal across a corner, such as shown here, should also be avoided.

This shows the slight adjustments that can be made. Always check for uncomfortable positions which might creep into your composition without you being aware of them.

Placing the main interest right in the centre is dangerous, because the eye will be led directly here, and it then becomes difficult to arrange everything else comfortably.

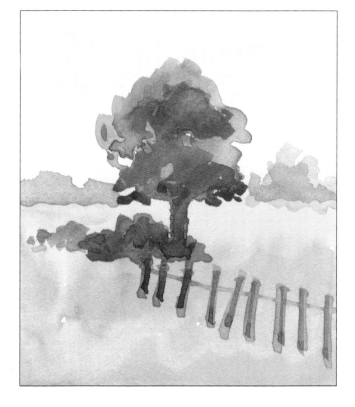

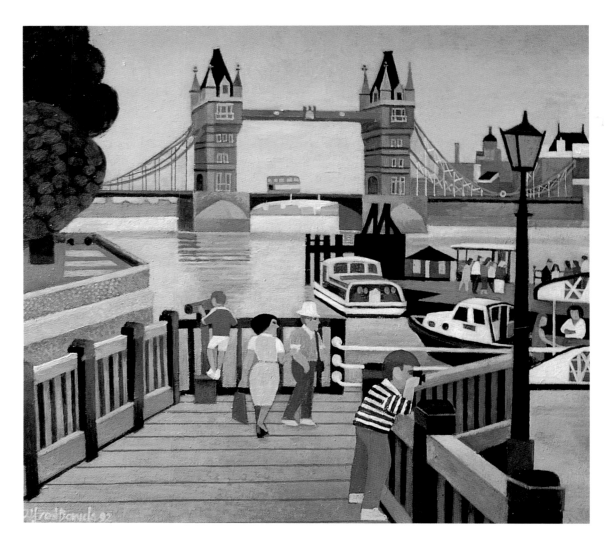

PREPARING A PAINTING

Composition isn't, of course, just about still life, but about every subject you choose to paint. If you feel that the word 'composition' sounds rather intimidating, think instead in terms of arranging things comfortably with each other, just as you might 'compose' an outfit of clothes and accessories, taking into consideration the colours, shapes and the overall effect.

By now you should know just what you want to paint and have all the sketches and notes ready. Your intention should be clear and you should be ready to work towards a final painting. Here is a good basic plan to follow. Any tools can be used for these stages. Try graphite pencils, coloured pencils, pastels – anything you have to hand which you can use with ease and confidence.

Alfred Daniels,
Tower Bridge Jetty,
40.5 x 30.5 cm (16 x 12 in),
acrylics.
In this painting there is a central interest, but the complexity of the subject and the skill of the artist make the composition work.

THE COMPOSITION

Having decided on the most important part of
your painting, it is now necessary to place it
happily with the other elements of your picture.
Even if you are translating a straight drawing of,
say, a landscape, this has to 'fit' onto your paper
in a subtly balanced way, and you may need to
shift a tree or add a bush or whatever. If you do
this, make sure you know how you will deal
with any 'gaps' you have created. Check that
you can take the eye through the composition in
just the way you want it to go.

THE FORMAT

The next important stage is to work out the
format. Sometimes it is possible just to draw a
line around a rough drawing and go on from
there. At other times you may wish to make a
working drawing inside a format you think will
be suitable and adjust this as your drawing
develops. With gouache as well as with other
water-based paints, there is no need to be
pinned to a specific size or proportion if you are
working on paper or watercolour board.

 If your arrangement begins to overrun your
planned oblong, don't worry; this is a stage most
of us go through. Working out where to put
what and what to put where is part of the puzzle

Ronald Jesty,
Loch Kinardochy,
18 x 42 cm (7 x 16½ in),
watercolour.
The choice of format suits the
panoramic view.

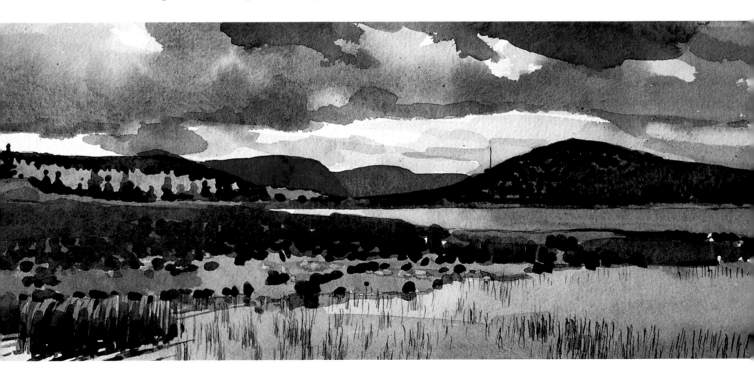

and challenge. Keep everything free and loose, and therefore movable, until you begin to see how the composition works best. Try not to rub out or start again before a rough has come to a form of completion ready for the next stage.

Alternatively, a sheet of working drawings which you can use for reference is a great help. Make your first rough ideas fairly small and re-draw on them or develop them on the same sheet of A3 or A2 paper, so that you can see all your thinking processes as they happen.

▶ Finished basic rough and tonal rough: changes can still be made to the composition even at these stages. Nothing is final. It is important to make sure that, whatever colours you use, the tonal balance works.

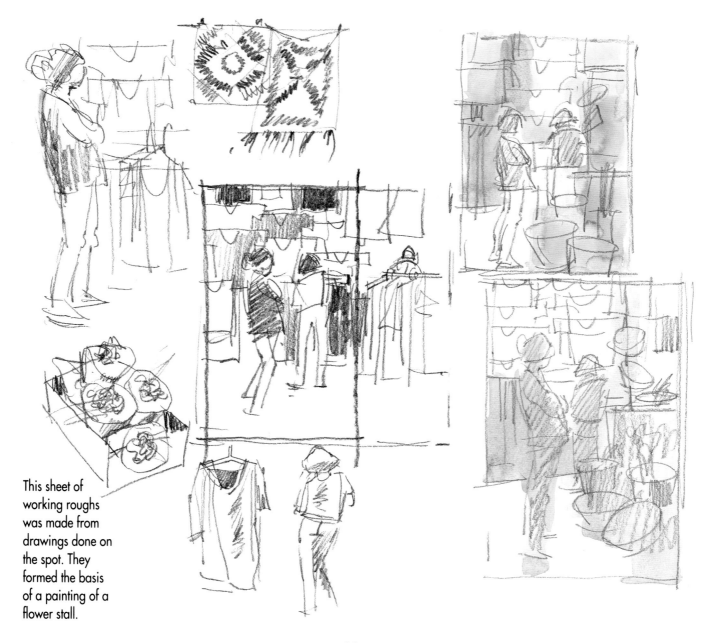

This sheet of working roughs was made from drawings done on the spot. They formed the basis of a painting of a flower stall.

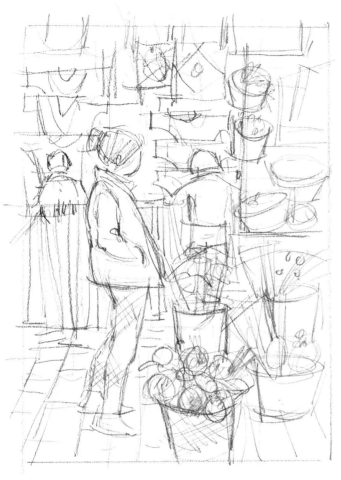

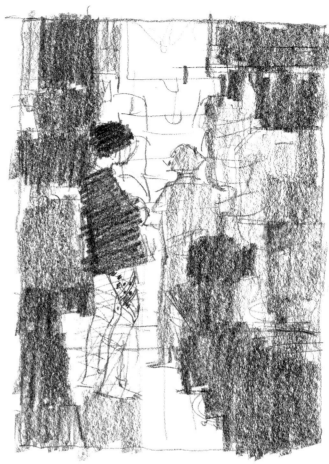

THE FINISHED ROUGH

When you have decided on the proportion and the main parts of your painting, it is time to make the first 'finished rough' (a contradiction in terms, but it will serve here as an indication of what I mean). In this context a 'rough' is the term given to a basic working composition rather than to a rough (scribbled) idea drawing. It should be of a reasonable size – perhaps half the size you plan to make your painting. There need be no detail, but it should show quite clearly how the final composition will work on your paper. All the parts of your work must be comfortable with each other; the eye should be led from part to part and come to rest for a while on your main interest. The eye should never be carried out of the picture!

Tone and colour will also function as direction setters and focal points, since the eye is attracted by contrasts and intensities. Refer back to Chapter 4: Tone and Colour, and do a few more experiments of your own to make sure you understand this.

THE TONAL ROUGH

Now is the time to trace your composition (so that the first working rough remains unspoiled for reference) and to add tone to the traced drawing. Layout or typographical paper, available as pads, are ideal as tracing paper, although greaseproof paper would do at a pinch. Make sure the tones you add are general areas rather than shaded details and that they enhance your composition. This stage is called a 'tonal rough' and should be well-balanced, effective in tonal relationships and should aid the voyage of the eye over it.

THE COLOUR ROUGH

A second tracing should be for a 'colour rough', and for this you may need sturdier paper. The main areas of colour should be as near as possible in tone to those in your previous rough, so that you can see how colour and tone will work together and what adjustments to make. And again, no detail is necessary at this stage.

If, in your judgement, the rough is nearly the way you want it, then just make any small final alterations. When painting out or over gouache, make the changes with colour that is not too wet and is opaque enough to cover – and don't stir the paint around, or you'll begin to lift the paint underneath.

However, if a lot of changes are required, it is best to make some further roughs until the arrangement of subject, colour and tone are as you want them. Sometimes it is possible to paste a patch of paper over an unsatisfactory area and paint on that, 'marrying' the edges to the areas surrounding it.

ENLARGING THE FORMAT

When you have completed your final rough, you are ready to transfer it to your paper, which should be stretched if necessary as described on page 17. To enlarge the rough to the correct size and in the same proportion, refer to the diagram below. Remember that oblongs of the same proportion have a common diagonal.

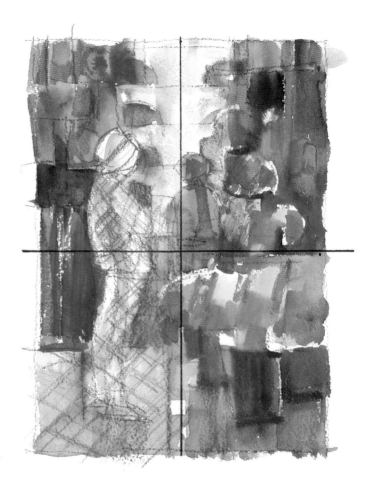

Colour rough: adjustments can be made to tones at this stage, but keep your overall tonal pattern in mind all the time (or make another).

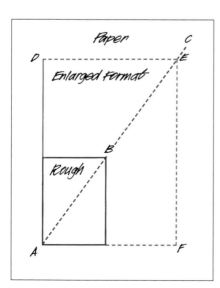

Enlarging the format: mark the size of your rough and draw a diagonal from **A** out to **C**. Extend the left-hand vertical to the height you want for your painting (**D**). Finally, draw lines to **E** and down to **F**.

PRACTICAL TIP

When you have established the size and proportion of your rectangle and drawn it in on your paper with a very faint line, try putting drafting tape around it, about 3 mm (⅛ in) outside the edges. This means that you don't have to worry about where the boundaries of your picture are or bother if the paint goes over them. When you have finished painting, remove the tape very gently and smoothly.

The finished work, enlarged from the colour rough, shows how much detail can be added as long as the basic tonal and colour relationships were established earlier.

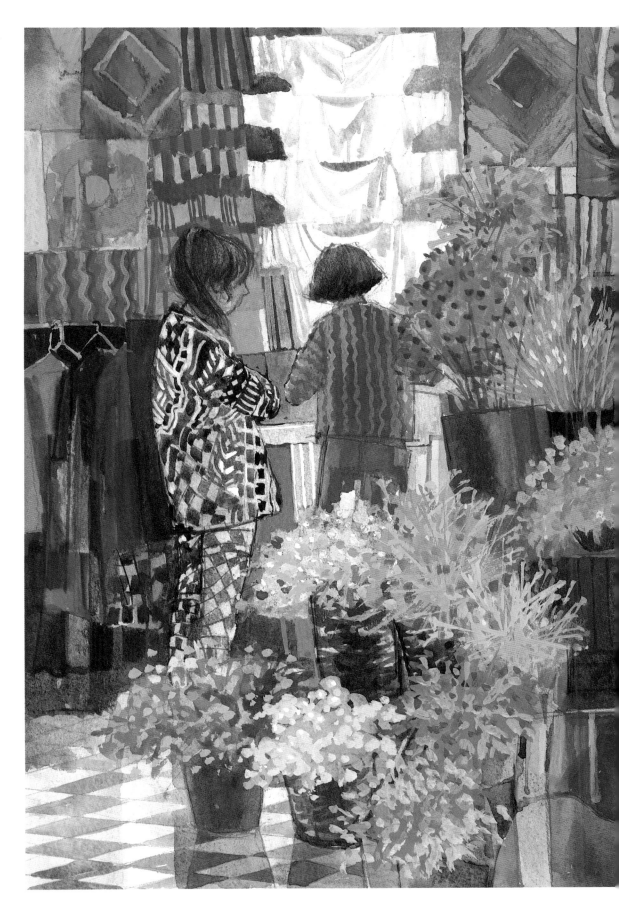

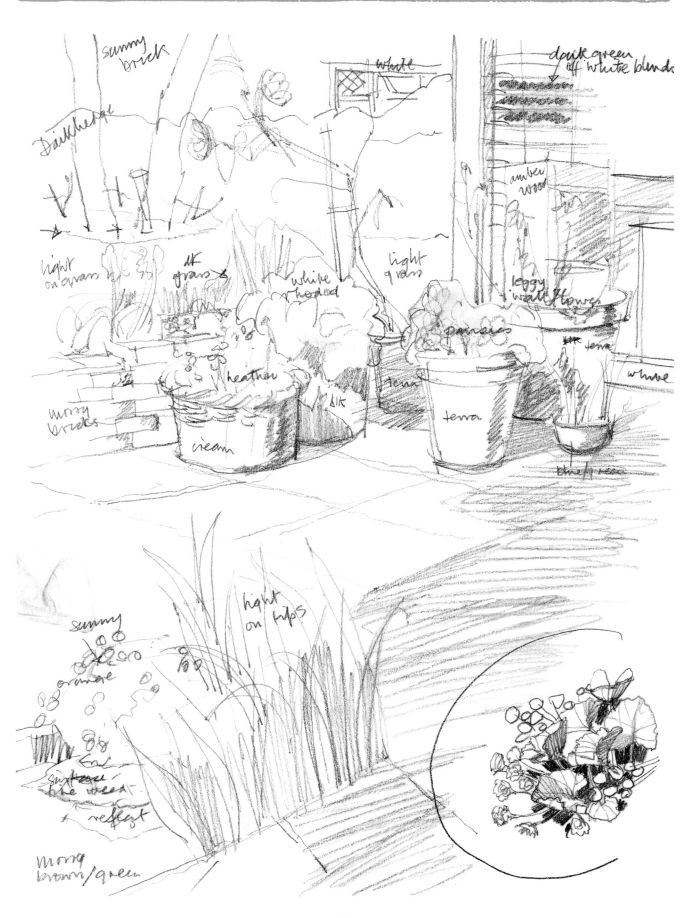

DRAWING IN THE IMAGE

If your idea is simple or the enlargement is not much bigger than your rough, you need only do a very light, undetailed drawing. If there are big changes in size, then draw faint horizontal and vertical guidelines across the centre of both the rough and the painting surface. Each quarter of the rough can then be transferred to the appropriate quarter of the paper. For very large paintings, each section may need to be divided into six or eight parts.

Try to transfer only a minimum of your drawing. Remember that you can alter as you go! If you are really brave and the composition is fairly simple, then paint straight away, using the point of a brush for drawing lightly with very pale paint, which should be thin but not wet. If you go wrong, add a tiny spot of another colour to your correction lines. Start thin and keep the whole painting area developing. Establish colours and tones before building up detail.

◀ This drawing was made on the spot as a practice exercise. At this point there was no real intention of making it into a painting.

▲ The colour sketch was also made on the spot to supplement the first sketch. The colours are 'local' and not very interesting.

▶ Curiosity about the possibility of making a painting prompted two colour roughs. In this first one, the pots farther away were made bigger as they were intended to be a focal point, but the whole balance became too even and cut the composition in two.

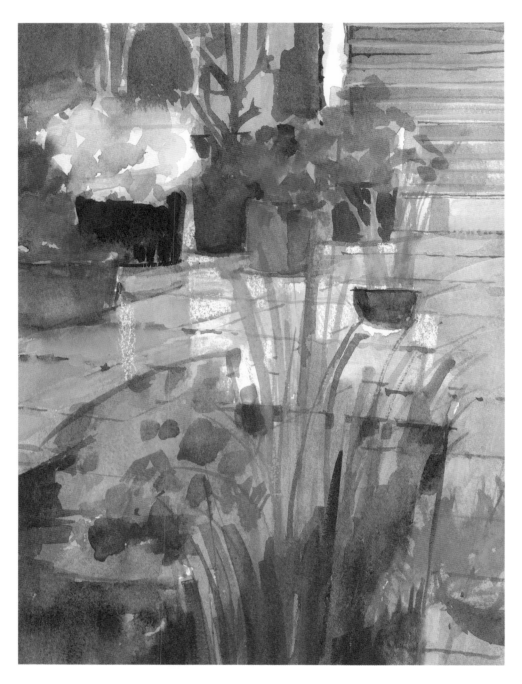

◄ In this second colour rough the pots farthest away were reduced in size but increased in number, so that the foreground became more dominant. The eye was carried from one group to the other by the blue pot.

► Doreen Roberts,
Patio Pond,
35.5 x 25.5 cm (14 x 10 in),
gouache.
In the final painting the relative sizes of objects and spaces were adapted to make the composition effective, and the decorative treatment meant that the foreground plant and leaves left enough space for the water in the pond to be given a more dominant role.

PRACTICAL TIP

It is frustrating if your first 'stage' of painting is still wet when you want to continue with it, so if you have a hair-dryer, use that, either on the part you want to work on first, or on the whole painting. A hair-dryer can also become a tool in manipulating small areas of texture.

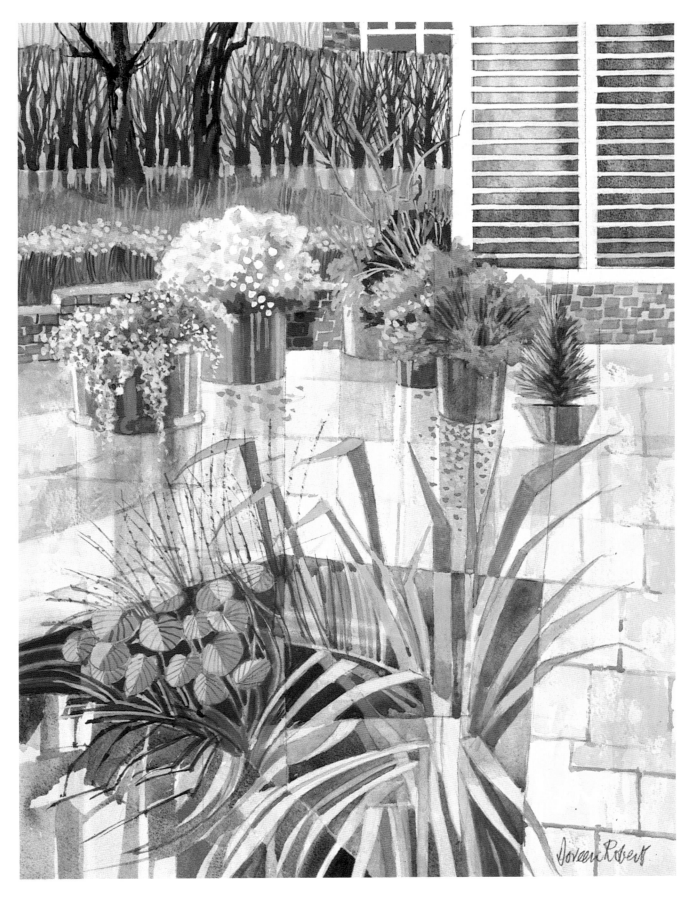

PROJECT
PREPARING TO PAINT

In preparation for a painting, which you can begin when you are ready, make working sheets of a variety of compositions for two still-life groups – one with fruit and stripes of some sort set against the light, and one of plants or flowers set on the floor so that you view them from above.

Alternatively, look in your notebooks/sketchbooks where you should by now have collected material ready for a personal idea, perhaps based on something seen outside your home, depending on where you live. Go through all the stages of roughs from composition to tonal and colour roughs, so that you are ready for the main painting.

Do at least three rough compositions of your subject, so that you can choose the most effective and be clear in your mind about your aims. This is particularly important if you are painting a 'scene' for the first time.

Stella Hunt,
Rhubarb,
gouache.
Here the projects given to my leisure group were 'Food', 'Cooking' and 'Mealtime'. This student saw some rhubarb seed heads which interested her, so she decided to make rhubarb her subject. She has included not only the seed heads, but also the leaves and the cooked fruit. Taking a theme is a good way to spark off ideas.

▲ Marjorie Neville,
Cups and Saucers,
gouache.
Rather than making a
traditional still life for her
project, this leisure painter
thought in terms of the objects
in a washing-up bowl.

▶ Jeanne Ramsay,
The Ploughman's Lunch,
gouache.
This leisure painter drew her
husband (making him fatter)
and asked a local baker to
bake the cottage loaf for her.
She made separate studies of
the parts first.

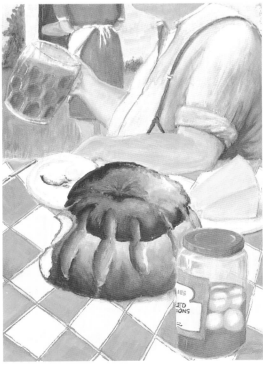

SELF-ASSESSMENT

✧ *Did you look for the
shape and colour of
shadows or did you just
guess them?*

✧ *Did you check the
effectiveness of any
spaces between your
objects, or between
them and the edges of
your work?*

✧ *Did you have enough
information about your
personal idea in your
notes and drawings
about it?*

TAKING A FRESH LOOK

If you come to a stop at any time while you are painting or feel that something about your composition isn't quite right, try turning your work upside down. Imbalances often show up when you see work from an unfamiliar viewpoint. Reflecting it in a mirror works well too. Otherwise, put your painting away for a week and come back to it with a fresh mind.

If you only want to take a break for a day go out for some fresh air and have a really good look at everything around you. Look for shapes, colours, textures – all the components of paintings. It doesn't matter if you see nothing that interests you enough to paint it; you will be training your powers of observation.

Whether or not you need to employ any of these methods, do move away from your work every half an hour or so, and sit and look at it critically from at least half the length of your room away. Keeping your nose glued to your work narrows your perception of it.

BOTTOM LEFT: Where possible, paint the surroundings first and establish main colour and tonal relationships. If you do this, you can spot any weaknesses and take action before you have gone too far. Make sure that you don't start with details or objects, leaving each of them surrounded by white paper. Everything relates to everything else – an important point to remember.

▼ Here some detail has been added and tones darkened. If there is a part which goes sadly wrong or if you want to alter something, it can be dab-sponged out gently and left to dry. Don't rub, and make sure the sponge (or tissue) is clean. Note that some colours cannot be sponged out entirely, but leave only a stain which won't be picked up by anything put on top.

▶ Doreen Roberts,
Broken Boat,
35.5 x 25.5 cm (14 x 10 in),
gouache.
This shows the finished painting with more boats added and textures completed. The seagulls were painted out as they were 'uncomfortable' between the two boats. The masts and ropes at the top of the painting compensated for their removal.

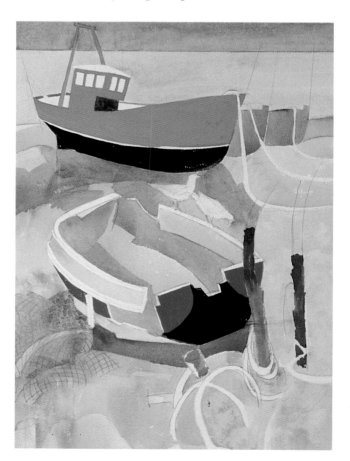

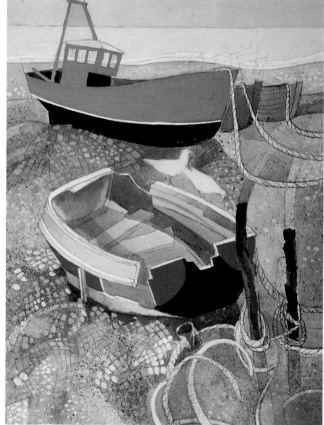

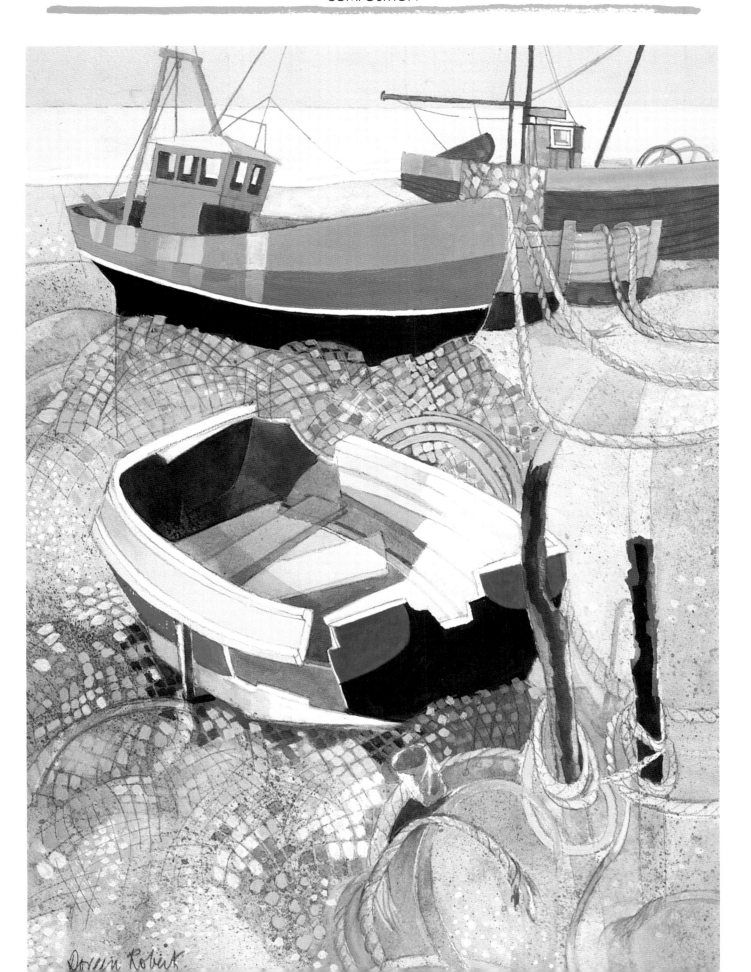

Doreen Robert

ATTITUDE

The main thing to remember, especially when you have no one present to advise you, is that painting is a problem-solving activity. Learning is achieved through trial and error. Painting is always a matter of finding out your own best way to express your ideas in paint. You might want to do it differently next year, but what you want to do and how you do it at the moment is what matters.

This was an experiment using thick watercolour crayons. Each leaf is treated in a different way.

EXERCISE

Take a painting which you have found unsatisfactory and which has posed specific problems. (I hope you remember to date your work on the back, and keep everything for a long time.) Without having this painting in view as you work, try to reinterpret it according to what you have learnt since you first made it. Even if it is still not satisfactory, this is a useful exercise which tests your ability to think around problems.

▶ George Large,
Caged Birds,
40.5 x 61 cm (16 x 24 in),
watercolour.
Although the eye moves comfortably from part to part all over this painting, it constantly returns to the three faces and the caged birds which form the heart of the composition.

USING OTHER MEDIA

If you have worked your way through the experiments and projects outlined in the earlier chapters of the book, you will, by now, have a basic understanding of painting in general and have become familiar with using gouache. You should also be well on your way to being able to initiate and carry through a painting on your own. With these skills well-established, you may now wish gradually to broaden your scope by changing the medium in which you work. Acrylics and watercolours are both used with water, so would be good media to try if you wish.

Different media require different disciplines. For example, acrylics dry quickly, while watercolours do not; acrylics can be used on any porous ground, whereas watercolour is best used with special paper. It is up to you to decide which, if either, you choose to try.

◀ This colour sketch of a kipper was made on watercolour board. You can see the original drawing through the transparent acrylic colour.

▶ Doreen Roberts, *Fishmarket*, 51 x 61 cm (20 x 24 in), acrylics on canvas. Here the paint has been applied directly, both thinly and thickly, building up the surface of the paint, as one might apply oils.

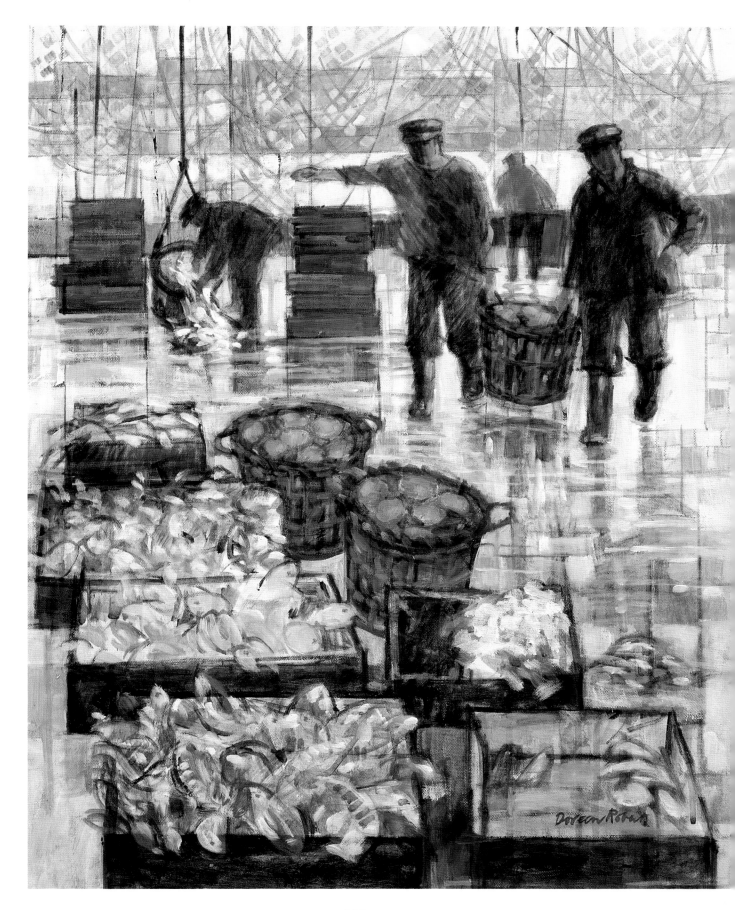

CHANGING TO ACRYLICS

Acrylic paint is polymer-based (polyvinyl acetate or PVA for short). It is slightly elastic, and is water-soluble when wet but permanent when dry. To demonstrate these properties, you can do an experiment with PVA glue and gouache. PVA on its own is a very useful white glue which looks milky, but when dry becomes transparent and waterproof. Dilute a spoonful of PVA glue with a little water and add some to a small amount of gouache. Now you have a sort of acrylic colour, successful or not according to how well you judged the quantities.

PRACTICAL TIP

If you are a messy worker or inclined to get paint on yourself, do wear an overall as acrylic cannot be removed from your clothes. Dried-on paint can be partially removed with methylated spirit, but it is not very effective.

From this experiment, you will see that using acrylics will be quite similar to using gouache. The big difference is that while gouache can be sponged off – and can also be ruined if you spill coffee on your work – acrylics cannot because of their PVA base. Acrylics can be altered by overpainting without fear of picking up the underpaint, but by the same token they can ruin your brushes by drying hard on them if you leave them out of water.

Acrylics can be used over, but not under, gouache, so with some PVA glue and gouache, plus a few tubes of acrylic, you can move from one medium to the other. The changeover to working with acrylics on their own can be as slow as you like. Of course, you may want to keep your gouache untouched and simply buy separate acrylics so that you can compare the characteristics of the two types of paint.

BUYING ACRYLIC PAINTS

Acrylics come in larger tubes than gouache, but are no more expensive relative to size. Buy the same basic colours as you did for gouache (see page 14). Remember that the different manufacturers have different names for the

Acrylic experiments on canvas board. Although seeing other people's techniques can be useful, it is always better to find out for yourself.

various types of paint, so look at the charts in your art shop. Whatever you do, don't buy beginners' kits as the paints may have names like 'Basic Blue' etc, which do not help you to learn the true colour names. Your round enamel plate, or any non-absorbent palette you have been using, will do for your acrylic paints – there is no need to buy anything new or fancy.

BRUSHES

Although the brushes you use for gouache will do for acrylics too, they won't make very big marks and they are not very tough, so you also need a few best-quality hog hair ones which are stiffer and hardier – the same sort of brushes as are used for oil painting. The longer-haired ones last longer, as do the better quality ones. There are also brushes made specially for acrylics. Start with a medium and a fairly large brush in flat square or filbert shapes, and a medium-sized round-ferruled brush.

Alfred Daniels,
Brighton Pavilion,
40.5 x 51 cm (16 x 20 in),
acrylics.
This shows clearly how acrylics can be used thinly.

PRACTICAL TIP

While you are working, leave hog brushes in clean water. With soft hair brushes such as sable, rinse them of paint and leave them out of water.

SURFACES

Acrylics will go on almost anything except totally non-porous surfaces like glass, plastic or enamel. They do not need specially prepared surfaces as do oils. This makes them very economical for beginners to use, as they can be painted on cardboard or wrapping paper, and even on the card from cereal packets and other such packaging. If you use the latter, or any thin overprinted card, you will need to give it a coat of white emulsion to block out the print. If the card is too thin, it will curl if primed on one side only, so cover the reverse side, too, to straighten it out.

You can also use any of the usual papers or boards suited to drawing or painting, and there are canvases and canvas boards too. Thin paper should be stretched as for any medium which may cause cockling.

DRYING

One of the advantages of acrylics is that they dry fast and are therefore easy to overpaint. This can be a disadvantage in hot weather, though, so put a drop of water on each paint squeeze on your palette every now and again. Retarding Medium, available in a bottle or tube, can be mixed with the paint to slow down the drying process. You can also buy Stay-Wet palettes to keep acrylic paints moist, although these are not usually necessary.

Try not to be intimidated by the speed of drying. It is not as fast as you think and can be helpful in building up a surface, or in painting out without having to wait or use a hair-dryer. I have only found drying a problem in a raging heatwave.

Doreen Roberts,
Hanging Gold,
76 x 51 cm (30 x 20 in),
acrylics on canvas.
This was made from a drawing done in the autumn in a local park. The paint for the water is transparent, but the paint for the foliage is applied more thickly.

PRACTICAL TIP

If the paint has dried on your palette when you come to clean it, put it in a bowl of hot water for about ten minutes and the colour will either just float off or can be peeled off.

Doreen Roberts, *Water*, 35.5 x 25.5 cm (14 x 10 in), acrylics on watercolour board. The movement of water has always fascinated me and my local park has provided a lot of opportunities to study it.

CONSISTENCY

Acrylics are of a similar, but juicier, consistency to oils. They are transparent when used thinly and have a very nice translucent quality. If you try to paint thickly straight away, you may find that the covering power is not strong, but it builds up well and, once you get used to it, you will appreciate acrylic like any other medium with its own character.

WORKING WITH ACRYLICS

You will, I'm sure, do this! Go through the same experiments as described for gouache on pages 22–23, but this time use acrylics to find out all the possibilities of this new medium. Don't be tempted to leave this step out. The basic way to apply acrylics is very like gouache, bearing in mind its own variations.

EXERCISES

1 Look out of your window at different times of day and in various weathers, and paint three skies which are interesting or exciting.

2 Go for a walk and draw a corner of a street with a gate and a small building which interest you. Make notes for a painting.

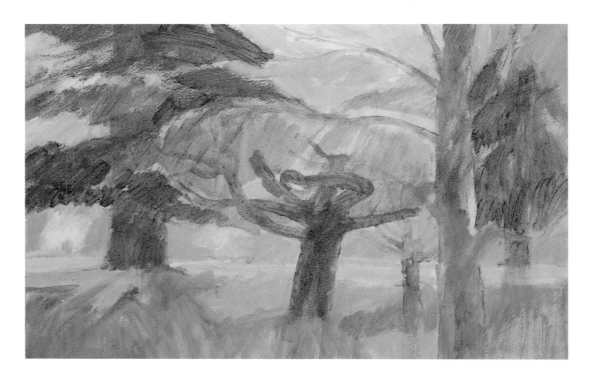

▲ Using acrylics on watercolour board, this shows the first 'blocking in' of tones and colours for an idea based on a tree in blossom.

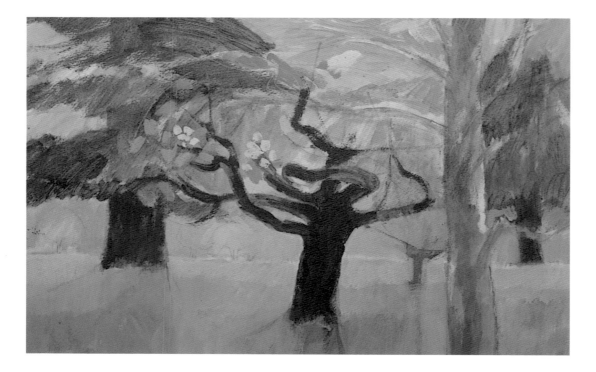

Here the light and dark areas have been accentuated and the structure of the branches made clearer.

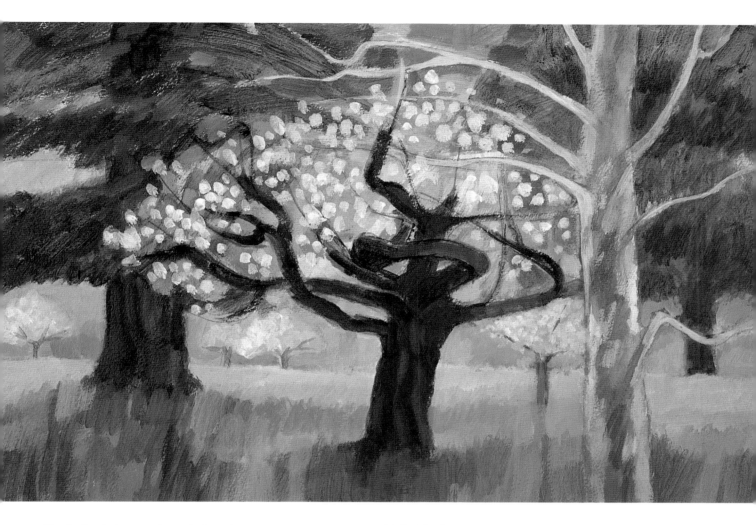

Finally the darks under the trees have been built up and the tree behind has also been darkened to allow for the detail of the light blossom to stand out more clearly.

BUILDING UP SURFACES

One thing which can be done with acrylics and not with gouache is to paint thinly over thick as one can with oils. Thin gouache must have a fair water content which will dissolve and pick up colour underneath, but as acrylics are waterproof when they dry, this can be turned to your advantage if you like the effect of, say, a thin, dark colour over thick lighter paint. Experiment with it before you use this 'technique'.

Although this 'demonstration' painting is quite small, it could have been at least two or three times bigger, giving more scope for textures, colours and details, especially in the foreground. Personally I see acrylics as a 'big' medium, although other people use it differently. Compare the broad treatment here with Alfred Daniels' flatter use of acrylics in the painting on page 105.

CHANGING TO WATERCOLOUR

Watercolour and gouache can be used together as they are both water-based paints, but remember that to get the best out of the former it must be used *wet*. The poor quality of much amateur work is caused by using the paint too dry and with too small a brush.

BUYING WATERCOLOURS

The best basic colours to choose are the same as those I have suggested for gouache and acrylic, except that no white is needed – the white paper is left unpainted for this. Consult your art shop's watercolour chart for the equivalent colours and always buy Artists' quality. Some people think it is economical to start with Students' quality which are cheaper, but the paints behave very differently and I can see no point in doing the learning (and spending!) twice.

Some manufacturers call their Students' quality watercolours by a brand name, so beware of this and make sure that your shop understands your needs.

▶ Shirley Trevena, *Still Life with Check Cloth*, 48 x 38 cm (19 x 15 in), watercolour.
This artist manipulates her forms in such a way that colour, shapes and patterns dominate. She uses her paint transparently, working very directly with it.

I made this sketch on the spot, sitting in my car. I had just a pad of watercolour paper and a very small box of colours.

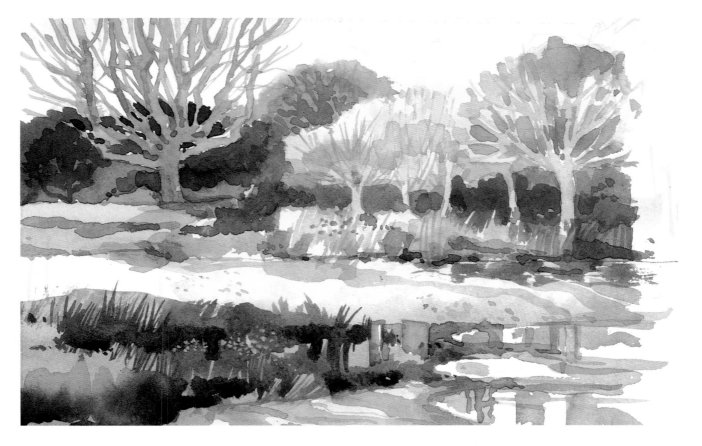

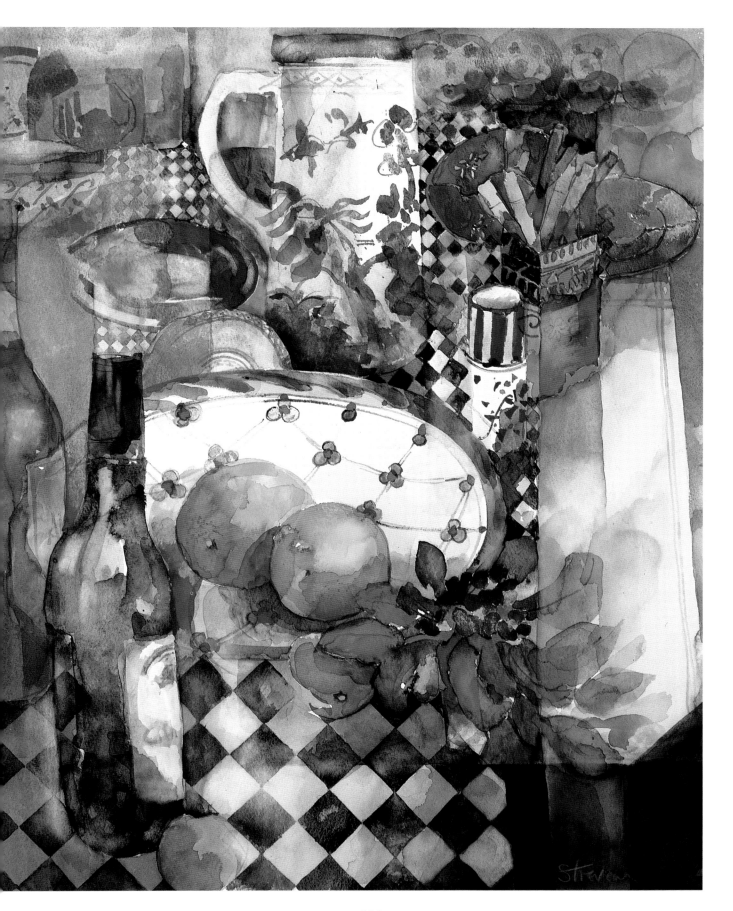

This is a pencil and wash drawing rather than a painting. Watercolour is effective used in this way.

PALETTES

For watercolour, palettes are extensions of the painting boxes – but do buy an empty box and fill it with your own choice of colours. You can buy watercolour in either pans or tubes. Tubes dry up quite quickly, so unless you are going to spend a lot of your time painting, buy half or whole pans instead; the number of colours a box will hold varies according to its size. I find a 12 or 16 half pan box or a 12 whole pan box is adequate – whole pans give a bigger paint surface supply.

BRUSHES

Brushes for watercolour must be soft-haired, preferably sable, but otherwise the best you can afford. The way to test brushes before you buy was dealt with on page 13. For watercolour, it is better to start with one good brush (a no. 9 or no. 10) which comes to a really fine point, so that the one brush can then be used for washes as well as for fine work. If you work fairly small, then a no. 7 would do. Later on you can add other sizes and shapes. Never leave a watercolour brush in water as it could be damaged.

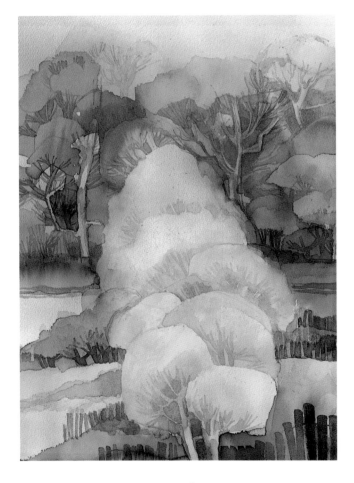

In this watercolour painting of trees, the main areas of amber and blue were laid on first and the detail was painted in afterwards to give an impression of individual shapes.

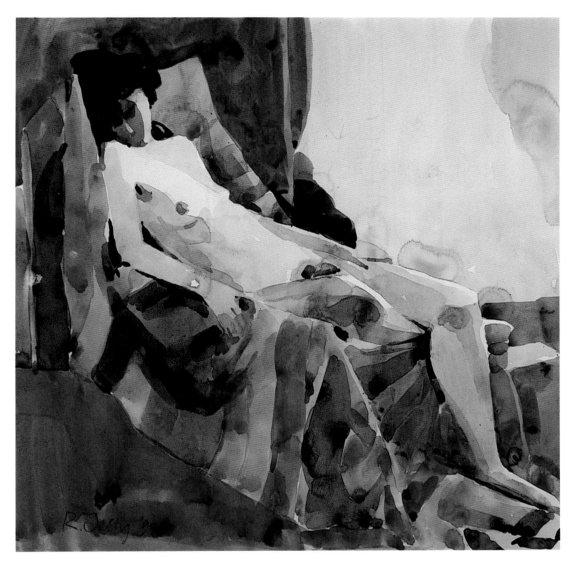

Ronald Jesty, *Sleeping Nude*, 38 x 38 cm (15 x 15 in), watercolour. Here the watercolour has been used very transparently and shows how this medium can be used effectively to portray the complexities of the human figure.

PAPER

The different types of watercolour paper have been outlined on page 16. How to stretch paper to prevent it from cockling is described on page 17. Try a sheet of each type to find out what is best for your sort of work. Pads are expensive, although you should have a small one if you want to make colour sketches outside the home. These are things which you can decide for yourself when you have tried the new medium out.

WORKING WITH WATERCOLOUR

Watercolour, like any other medium, has its own particular qualities and charm – but only when its character is maintained. It dries very much lighter than it looks on the palette, so you will need to get used to assessing this or your work will look weak or anaemic!

Watercolour should always be used wetly with the brush fully charged with paint and should still look wet when it is dry. This is why a big brush is a boon, as it can be loaded with colour and the colour 'flooded' on; a good point to the brush means that it will also do fine work.

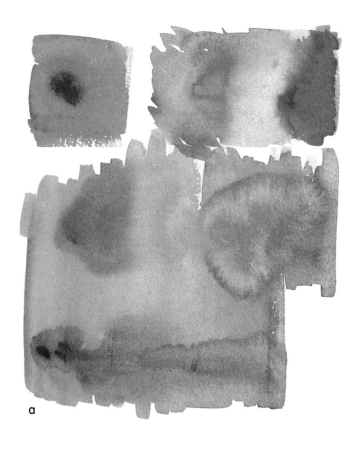

a

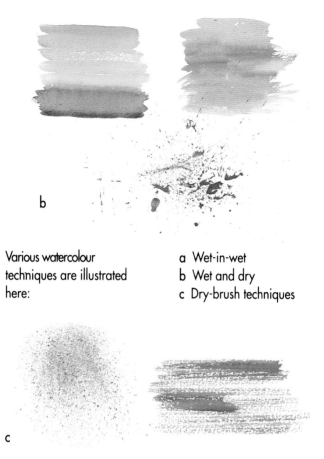

b

c

Various watercolour
techniques are illustrated
here:

a Wet-in-wet
b Wet and dry
c Dry-brush techniques

Use the reservoirs in your palette to mix enough colour before you start. A common fault with beginners – and with more advanced students who lack judgement – is to 'stretch' too little paint to cover a large area. The paint will streak and look dry, or you will have to pause while you mix more. Often one of two things happens (or sometimes both). Panic sets in and some fresh colour is mixed hastily and too dry, or the colour already on the paper begins to dry and, on adding the fresh colour, a demarcation shows between the two.

Some professionals can manipulate their paint in an amazing way and yet still keep the wet look – but these are superbly skilled artists and know their medium inside out.

Putting on a wash

When applying a wash, the brush must be loaded with wet colour and each brush stroke must overlap the previous one. The wetness must be maintained, but when you have

finished, take up any residue at the bottom with your brush squeezed out, or the paint will seep back into the wash.

Seepage is often seen as an imperfection in a wash, but it is a good example of an accident waiting to be turned into an advantage. As with all media, 'mistakes' can be used as part of your own technique if you learn how to control them.

'Wet-in-wet'

This is a term for the most usual way of using watercolour. It simply involves adding wet paint to that still wet on your paper. The skill depends again on knowing just how much paint to use and at which point fresh colour should be added. If it is added too soon, it will run all over the place; if too late, it will create streaks or dry areas and edges. Judgement needs practice.

Dry brush technique

As its name implies, with this technique the brush is loaded with just enough paint for it to

This sky was made in pure watercolour. Compare it with those illustrated on pages 50–51.

touch only the raised grain of the paper. From this, you can see that a rough paper gives greater opportunities for the technique. However, it will work on any surface if you learn just how much paint to use and how dry it should be. If you want to paint over something, then wait until the underpainting is dry (remember how you can use your hair-dryer!).

PRACTICAL TIP

As watercolour always dries lighter, try out your colours and learn to judge exactly how much tonal difference you can expect.

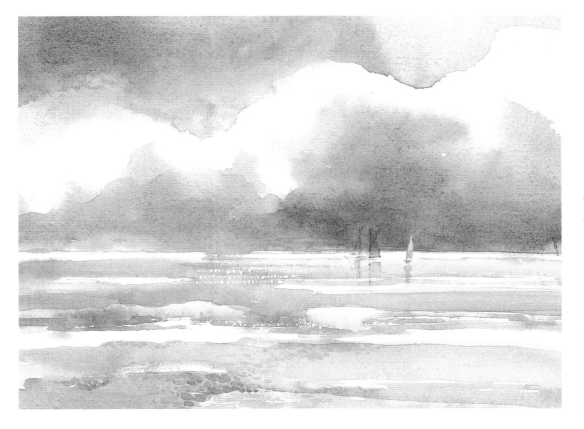

This quick watercolour of the sea and boats shows how paint put on with a well-loaded brush can be used to create hard or soft edges, or can be allowed to run from one colour into another.

PROJECT

USING WATERCOLOUR OR ACRYLICS

Using either watercolour or acrylic paint, and making adjustments in size, scale or technique according to the medium you choose, make a painting of one of the subjects given below. In either case try to create a different mood from the one you see. Use available light, but transform its colour if you can.

1 A small building like an outhouse or shed – one which has really interesting textural surfaces and is adjacent to or affected by some natural growth textures.

2 A still life with toys or tools. If you have no toys available in your home and cannot borrow any, then make a group from hats and scarves, gloves and bags. Try them in different settings before you start to work out your roughs.

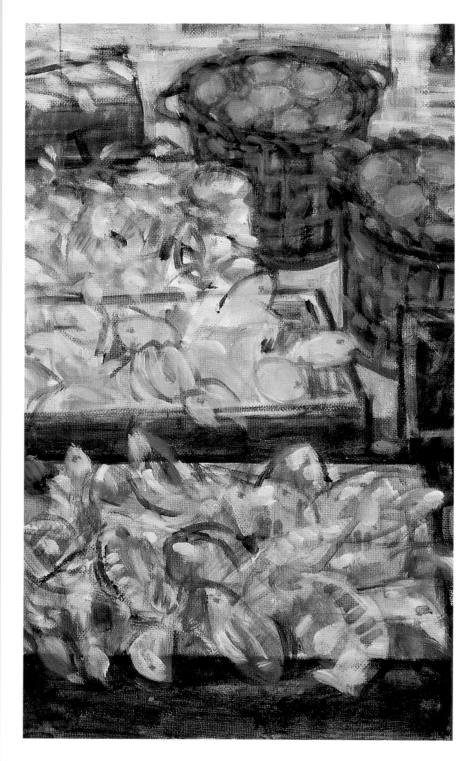

Detail of *Fishmarket* shown on page 103. In this close-up it is easy to see how the brush strokes suggest fish and crabs without exact imitation. Notice how the texture of the canvas can be seen.

116

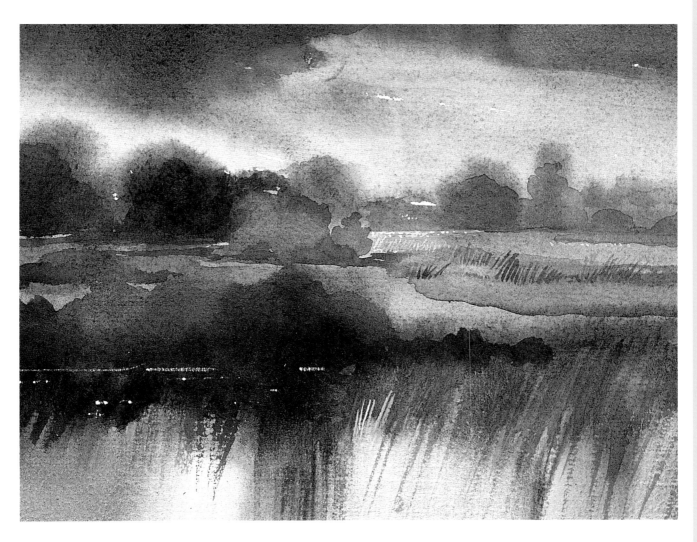

▲ Doreen Roberts,
Stormy Landscape,
21 x 30 cm (8¼ x 11¾ in),
watercolour.
This idea was sparked off
partly from an area
remembered and a thundery
sky observed, and partly
from imagination. Notice
how the tonal changes are
made to work.

Acrylics on fairly smooth
watercolour board are used
here to show the textures in
an old stone wall.

SELF-ASSESSMENT

✧ *Did you find that you
had done enough
experimenting before
you began?*

✧ *Did you remember to
keep the natural
character of your paint
rather than try to make it
behave like gouache?*

✧ *Did you allow for the
different speeds of drying
of your paint?*

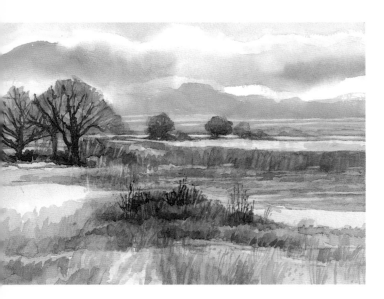

This watercolour landscape was painted entirely from imagination, showing how one can make use of one's visual memory.

▼ This painting shows how watercolour can be used effectively with pen.

STARTING TO PAINT

Go through all the stages of preparing your painting as described in the previous chapter and then transfer it to the watercolour paper very lightly in pencil, but with no detail. With watercolour, unless you are experienced enough to paint straight off, some drawing has to be visible while you are working so that you know where you are. But draw as little as possible, as I said in the previous chapter, or you may find yourself 'colouring in' your pencil lines.

To remind you again, do make sure that all parts of your painting, including spaces, are related rather than treated as separate elements. For instance, it will help you if you establish the sky and ground first in a landscape; the spaces first in a still life; and the setting first in a picture of people. In all cases, details come last. There is ultimately no right or wrong order, but this is a wise way of proceeding until you are expert enough to make other methods effective.

If you have done your usual experiments with watercolour, you will have discovered your own way of creating textures, perhaps using oil pastels as a resist. However you manipulate watercolour, remember that, when dry, it should still look wet and fresh.

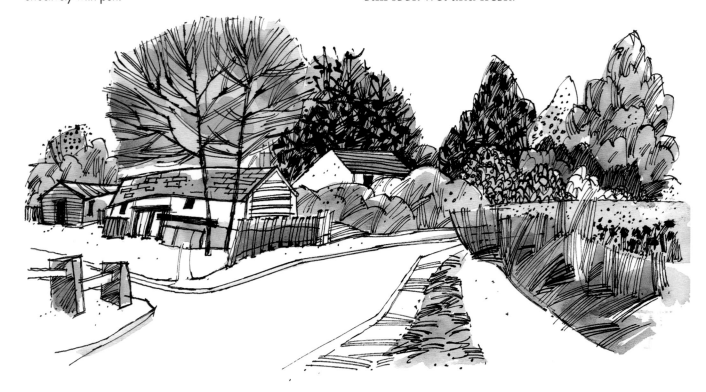

Richard Plincke,
Kettledrum Crescendo,
54 x 72.5 cm (21¼ x 28½ in),
mixed media.
In this painting, the artist
used watercolour first, then
sprayed on enamel and
added a limited amount of oil
pastel. His work has an
architectural element and his
interest in music suggests
rhythms, in this case with
sound waves and the
convergence of abstract
forms in mind.

EXERCISES

1 Paint a tree. Look for the masses of foliage which
vary according to the direction of light. Pick a time
when there is strong light of some kind, so that colour
and tonal changes can be seen.

2 Paint a vase of flowers or a potted plant placed at
eye level on furniture in a corner of a room. Make an
interesting setting for it.

LOOKING AT STYLE

It is almost impossible to define style in painting. It is a synthesis of all the aspects of painting dealt with in this book, and something else – the mystery ingredient which depends on character, personality and motivation as well as on skill. In fact sometimes, though rarely, technical skill has little to do with it! Our painting style is rather like our handwriting; we learn it in one way and then it develops as we mature. So the main ingredient of style is our personal approach to our work.

We live in an age where events happen with disconcerting speed; our world is changing faster than it ever did and, however much we might cling to the old ways, new attitudes are valid and can be used to express our view of our society in our paintings. The greatest artists of each age have done this, and many have suffered because their ideas were ahead of the rest of their world. There aren't many painters in each generation or even century who could qualify as 'great', but the rest of us should at least try not to hold back innovative ideas in painting. We can cultivate a personal way of seeing what is now rather than what is past – and this will to a certain extent affect our style. We develop only through time and practice, passion and ideas.

Throughout this book I have shown the work of other artists painting in different ways and in different media. In the following pages you will find paintings by a number of well-known artists who have written about their work. It is sometimes difficult to express ideas verbally when they are about complex visual concepts, but most people are able to convey why they chose their particular subjects and how they regard their work and their approach to it. Styles grow from this and personal techniques contribute to the visual expression of ideas.

It is always exciting to watch experts at work, and hearing their views on their art is a privilege not to be missed or taken lightly, bearing in mind that such experts are offering information about their life's work. I hope that you will find inspiration in the expression of ideas and concepts in this book and that your perception of the world around you will be enhanced.

Doreen Roberts, *Cliffs and Net Sheds*, 35.5 x 25.5 cm (14 x 10 in), gouache. In reality the rocks were browner and there was more greenery, but the colour was adjusted to work with the buildings.

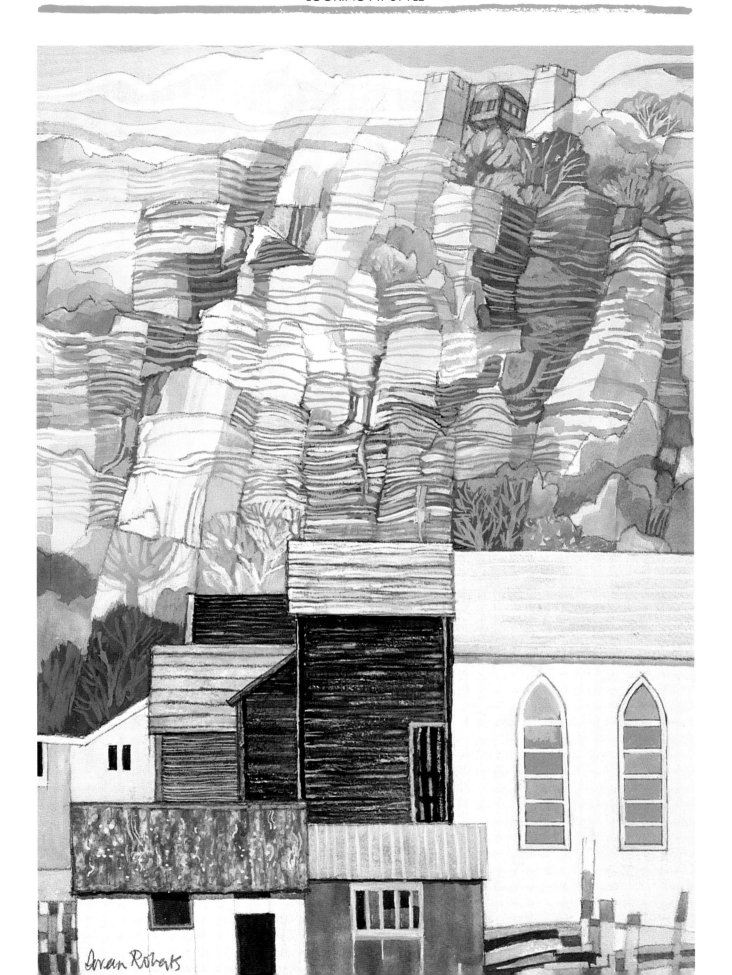

Arran Roberts

PETER FOLKES

For a long time I have had an affinity with the rolling downlands close to my home and find these hills a continuing source of inspiration.

I had been tutoring at Plumpton in East Sussex when I first saw Ditchling Beacon, and I determined to paint it on the day the course finished, before returning home. I spent three hours working on the spot producing a half-sheet watercolour. It became necessary to distort the landscape in order to fit it comfortably into a rectangle and to simplify some of the areas to prevent the painting becoming fussy. One cannot copy the vastness of nature on a small rectangular sheet of paper. Changes constantly have to be made through 'thought' and through 'argument', combined with 'feeling' and 'emotion' engendered by the subject.

Although the 'on-the-spot' painting had some merit, I wanted to start again on a larger sheet of paper and chose Not 300 gsm (140 lb) paper, which had been well soaked in the bath before being stretched onto a board and secured with gum-strip. The height and majesty of the Beacon had to be better established, which led to widespread distortion in the way the composition evolved.

I have always been an indifferent colourist and find myself far more attracted by texture and the rendering of the form of the hill masses. Light and shade were used to express the changes of plane and to heighten the drama of the scene. The sky was invented to contribute to the emotional feel of the work, so that it played a part rather than becoming an empty area irrelevant to the picture.

There are always so many different decisions to make. For example, should I leave out the fence or include it? What function would it perform? Too many details will destroy the force of the work, yet I decided the fence would serve to give a sense of scale by using the posts to indicate the size of a man at different distances in the painting. On the other hand, the small bushes and trees which grew on the hill looked like mould from a distance, so I decided quite firmly not to include them.

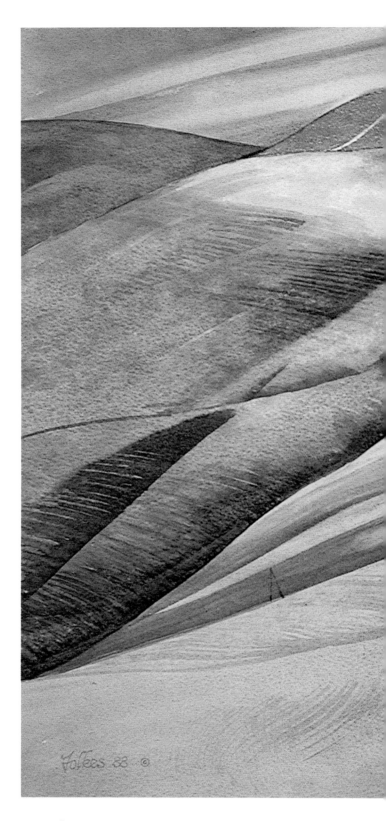

Peter Folkes, *The South Downs from Ditchling Beacon*, 38 x 56 cm (15 x 22 in), watercolour

122

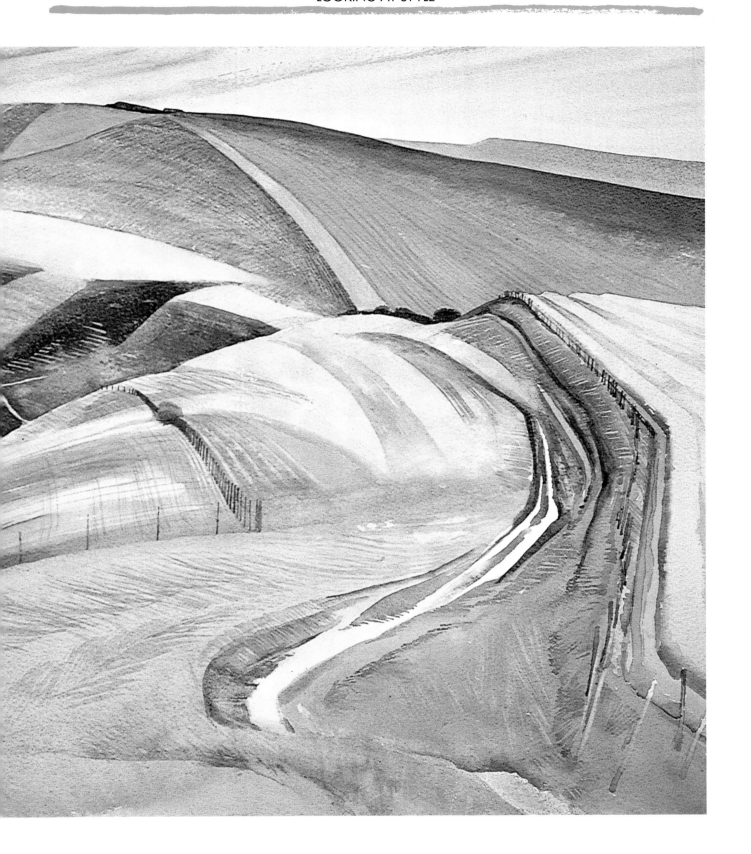

RICHARD PLINCKE

This painting came about partly from the inspiration of pattern and partly from the enjoyment of texture – effectively explored by such artists as John Piper and Graham Sutherland. Painters are forever searching for subjects that have meaning for them; for my part, I look back to a special moment when I once came across some old railway sidings and abandoned sheds deep in the countryside. The pattern and texture created by the old wagons and disused tracks spread out below me was so fascinating that I returned the next day, set up my easel, and painted the scene.

Much the same process occurred with these tiles, found in a semi-derelict building in Italy, their pattern largely obliterated by decay and debris. The inspiration is similar to that earlier example: runnels of cement-like substance, mould, cracks, with shapes and framework underlying all – embellished with the patina of decay. Painting of this kind can be compared with the enjoyment of intricate jewellery, or the carved surfaces in a Celtic Cross.

The technique is more difficult to describe except in the simplest terms. The textural effects are obtained by the use of sprayed enamel, especially when applied over well-soaked paper. I have found that a further, and useful, complexity is achieved by the interaction between one colour of enamel and another, moving the paint in various directions over the paper while in a thoroughly wet condition. Once the drying process begins, this is no longer possible; instead, a more general sprayed effect predominates. Both ensuing textures work well alongside each other. The more conventional watercolour technique occurs before, during, and after those necessarily hit-and-miss applications, providing a more secure framework and giving substance to the painting.

▶ Richard Plincke,
Florentine Echo,
53 x 48 cm
(21 x 19 in),
watercolour and
enamels

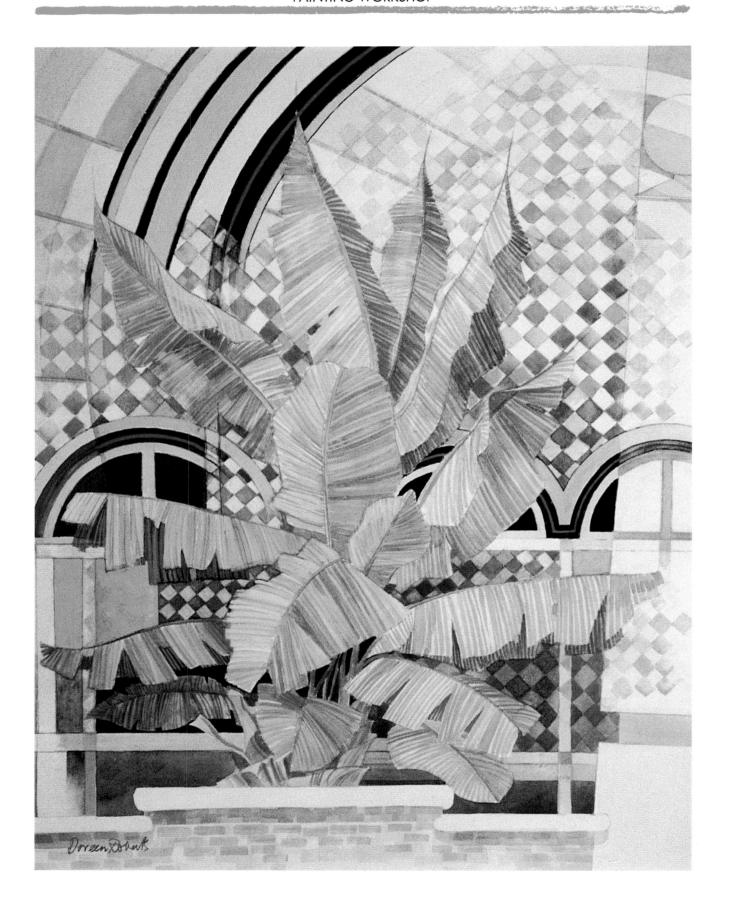

DOREEN ROBERTS

The Palm Court at Alexandra Palace in London is very light and decorative. The doors around it are mirrored so that the place seems fragmented. The large papery palms contrast well with the small check patterns on the walls.

Although I enjoyed looking at the whole, I didn't want to paint it all, nor make an architectural painting using conventional perspective to re-create an enclosed space. As I wanted to exploit the decorative qualities in a fairly two-dimensional fashion, I had to find a way of binding together the parts I liked best, so that they would form a convincing and cohesive statement.

I made drawings on the spot of the areas which interested me most (see page 79 in Chapter 5: Looking for Ideas) and made a few colour notes with written additions. When I got home I didn't like the shapes of the particular palms I had drawn, so I used a drawing I had done elsewhere of a banana palm.

Before I started work on the composition, I tried to see the whole subject in my mind quite clearly and to picture how the parts would relate to each other on the surface of my watercolour board. I wanted to show not only the difference between the door arches and the barrel arches of the roof, but the relationship between the pleated paper look of the palm leaves and the diamond patterns. It seemed that the best way would be to concentrate on using straight and curved lines, which are the main characteristics of the subject apart from the tensions between natural and man-made objects.

Although nothing in the finished painting makes architectural or spacial sense, the Palm Court is identifiable and gives an idea of the general feeling rather than that of a specific area.

◀ Doreen Roberts,
Palm Court,
36 x 46 cm
(14 x 18 in)
gouache

MOIRA HUNTLY

Venice is visually so stunning that it is not surprising that artists have always been attracted to the city. Round every corner there is an abundance of ready-made painting subjects and this quiet back street was no exception.

To begin with, I look at a subject in an abstract way, seeing it as a collection of shapes, a pattern of light and dark colours forming a composition. I was particularly attracted to the bridges and buildings of Venice because of the jumble of forms: rectangles, squares, triangles, semi-circles, and the interesting outlines seen against the sky. In my painting the sky area has in itself become an interesting shape.

Sometimes I paint on the spot, but more often I make drawings as a preparation for studio paintings. *San Barnaba* is based on a fairly accurately observed sketch in black conté pencil. I only add colour notes to a sketch when necessary if, for instance, accuracy is required for a commissioned work, or if I simply want to remember an exciting colour combination. On the whole I find that painting in the studio from a black-and-white drawing enables me to impose my own choice of colour, interpretation or mood more easily than when painting on the spot. Here, for *San Barnaba*, I was trying to create an atmosphere of soft, cool light and I experimented with a limited palette, starting with freely applied washes of Ultramarine Blue and Viridian, warmed up in parts with a little Raw Sienna.

I am not conscious of style when I am painting; I think it evolves naturally, but perhaps painting techniques have an influence on style. My usual technique is to start with a very large brush and cover most of the paper with very loose washes which I gradually pull together, superimposing the subject with smaller brush marks, while at the same time judging how far to take detail. Light areas are reinforced with creamy, opaque gouache, which at the same time defines and refines shapes. This method of underpainting and gradual construction of the subject comes naturally to me, and is a basis for all my paintings whatever the medium.

▶ Moira Huntly,
San Barnaba,
Venice,
43 x 31 cm
(17 x 12 in),
gouache

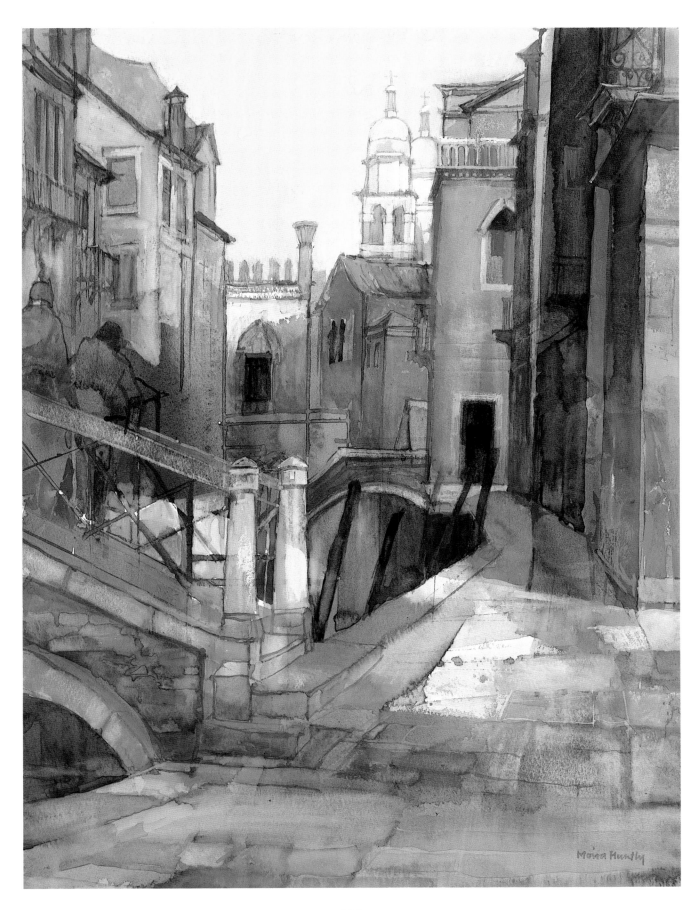

ALFRED DANIELS

As a born and bred Londoner I have always delighted in the sights and sounds of life in the city. I long ago learned that the best subjects were not in China or Peru, but in your own backyard. There is no need to go very far for good things to paint, and except for one or two deviations to fulfil commissions, this has stood me in good stead.

For many years I lived near Shepherds Bush Green in West London. What struck me about this area was the fact that the shops, cafés and markets were full of shapes and spaces, colours and textures that you could never invent for yourself, and yet it had them there for the taking. However, when I look about me, everything I see is chaotic. To deal with the confusion I impose an order. My order is one that concerns the *pattern of shapes*.

What kind of shapes do I use? Let me explain. When very young, I was apprenticed to a studio to learn lettering, signwriting for publicity and so on. It was through this discipline that I learned to understand and appreciate the value of letter forms, discovering that these letter forms were composed of geometric shapes, namely, the square, the circle and the triangle. Moreover, I found that when geometric forms were imposed on what I saw, it made the task of drawing and painting easier, and much more convincing.

Using geometric forms as a basis has moulded my way of working and characterized my style. In everything I have painted, you can see the principle in action. It is clearly demonstrated in the painting shown here, though it was not the sole reason for painting it. The main reason was because the station was about to be demolished to make way for a motorway junction. As it wasn't a classic example of architectural merit, it wasn't listed to be preserved; this meant that all the unique and delightful variations of geometric shapes and patterns, as well as the colour and life, would disappear forever.

Alfred Daniels,
*The Old Station
on the Bridge*,
41 x 51 cm
(16 x 20 in),
acrylic

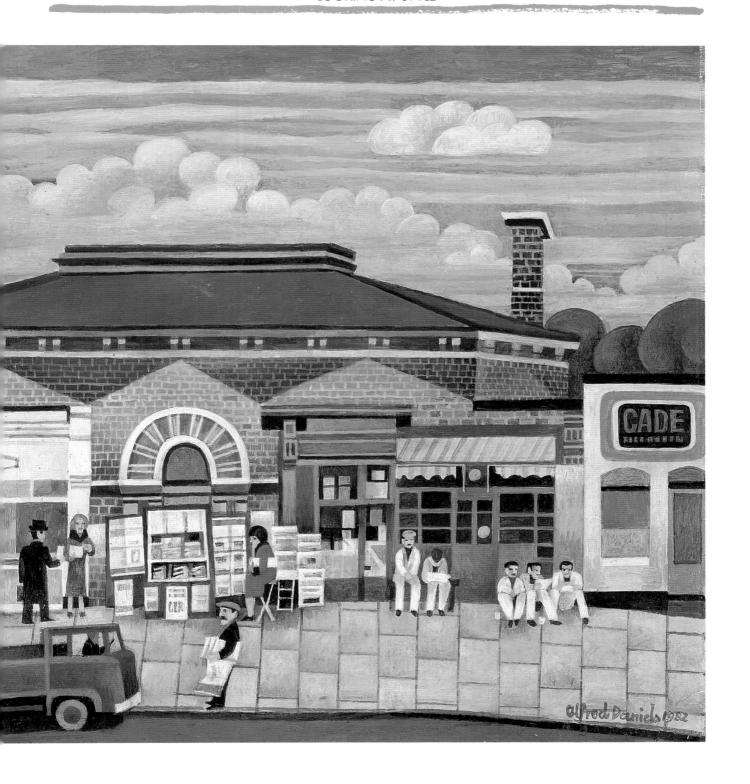

GEORGE LARGE

A swimming pool is an obvious subject for a figurative painter; nowhere can there be so many half-clad bodies interlocked with each other. They fit together like pieces of a jigsaw, giving splendid negative shapes and forming an overall pattern to the picture. Using the upright format means I can produce a slice out of the pool, giving more impact. All my paintings are fragments; there exists life beyond the edge of the picture.

All my work starts with drawings from sketchbooks. These drawings are usually background or small details. Sometimes four or five sketches go into producing the basic structures of the composition. When this is completed, figures are introduced by means of tracing paper over the original drawing. The final work is then transferred to 400 gsm (200 lb) watercolour paper.

The painting is initially restricted to no more than two colours to create an overall effect; also at this stage I establish the light and dark areas to form an even balance of shapes by producing a thick impasto and by blotting out areas to remove almost all the colour. This gives me bright and subdued areas throughout the picture.

When I feel that the right balance of the two initial colours has been reached, only then do I introduce more colours, usually very bright mauves, reds or greens. It is at this stage that the painting really starts – when textures and detail work come together and the painting really comes alive.

Textures are produced by scratching (with compass points or brush ends), with wax resist or just by using dry paint over the surface. These textures must be used sparingly to create the right amount of excitement or interest to the eye. To succeed, the painting must be a balance of these textures, plus shapes and colour.

My work is governed by the belief that an artist must create and not just reproduce the still life or landscape in front of him. Although based on realism, I distort, twist, add to and subtract from my original drawings. The area of the paper or canvas is the important factor, not the subject. Although all my work is figurative, I stretch or shrink an arm or leg to fit into the shape I require; the same goes for buildings or objects. Also the space shown in my paintings is very shallow; I bring the background into the foreground whenever possible, with colour or strength of tone, so there is an overall pattern in my work, not a spatial one.

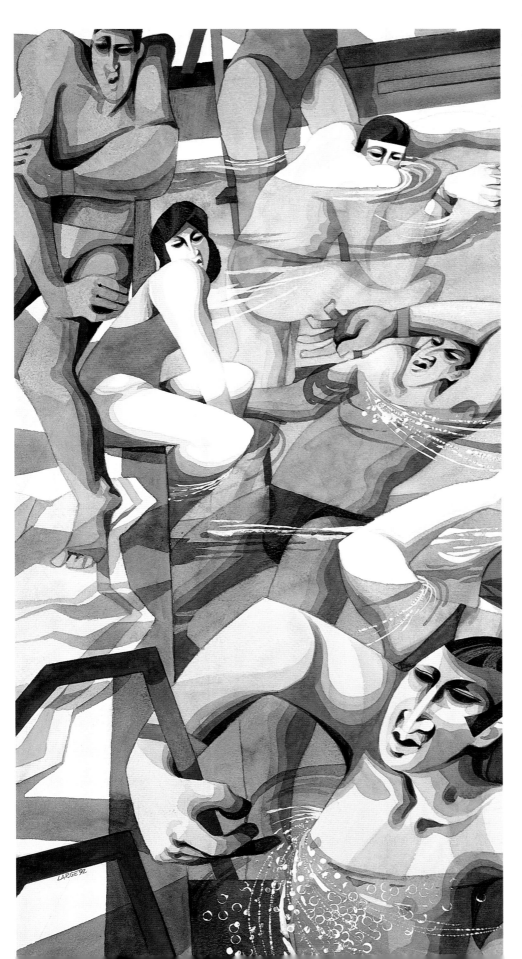

George Large,
Swimming Pool,
71 x 35.5 cm
(28 x 14 in),
watercolour

RAYMOND SPURRIER

I pass this view several times a week. It is so familiar that I scarcely see it, and only after somebody had crashed into the traffic roundabout did it spring to life as a subject for a painting. So I made some on-the-spot sketches in pencil with a few written colour notes and took them home to work on.

The result was a far-too-ordinary piece of representational painting that failed to make much of an impact. And it failed to encapsulate three of the things that interest me about landscape as a subject and which inevitably affect my painting style. They are, in no particular order of merit: the effect of man-made intrusions or additions to a more-or-less natural landscape; the two-dimensional pattern of shapes and colours that can be made to suggest a three-dimensional reality without recourse to Renaissance naturalism; and the way the elements of the picture can be simplified and arranged to make what has been called 'a landscape of symbols'.

To create this sort of image requires far more than straightforward observation of the facts. So I then got to work on a series of small compositional sketches incorporating the traffic signs and an almost abstract pattern for the hillside, with symbolic trees and bushes that are not far removed from the conventional signs on a map. Cloud shapes were formalized to match the style of the rest.

Any merit this painting may have I believe to be the result of careful design. When painting this revised version, I stuck to the overall pattern, though making instinctive adjustments to tone, colour and shape as I went along. This ensures overall unity in a self-contained composition that keeps the eye circulating within the picture space.

► Raymond Spurrier, *Star Hill*, 25 x 35 cm (10 x 13¾ in), watercolour

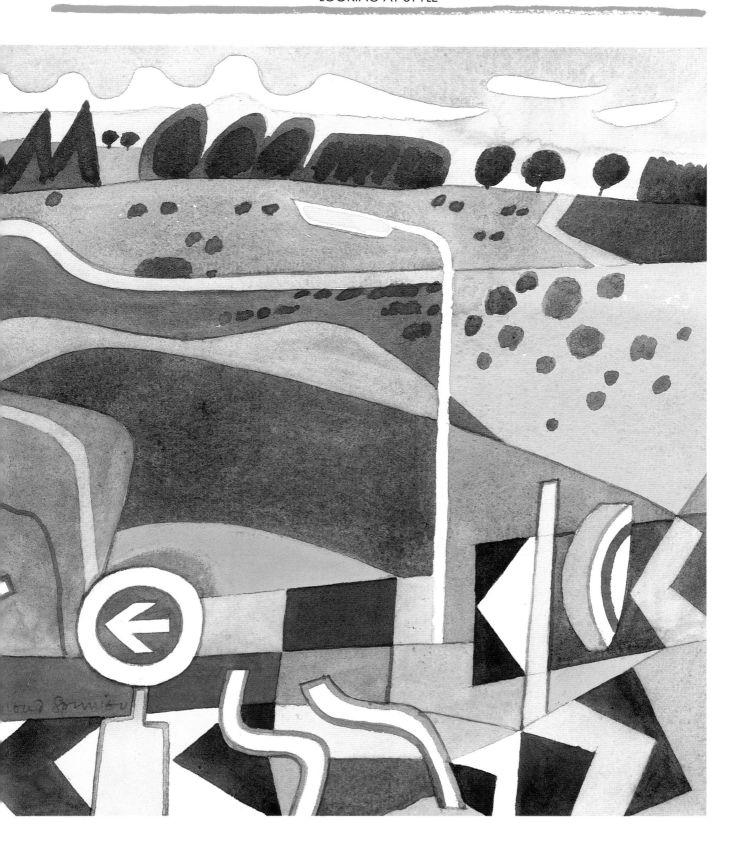

Ronald Jesty,
*Cloves, Lemon and
Garlic,*
33 x 20.5 cm
(13 x 8 in),
watercolour

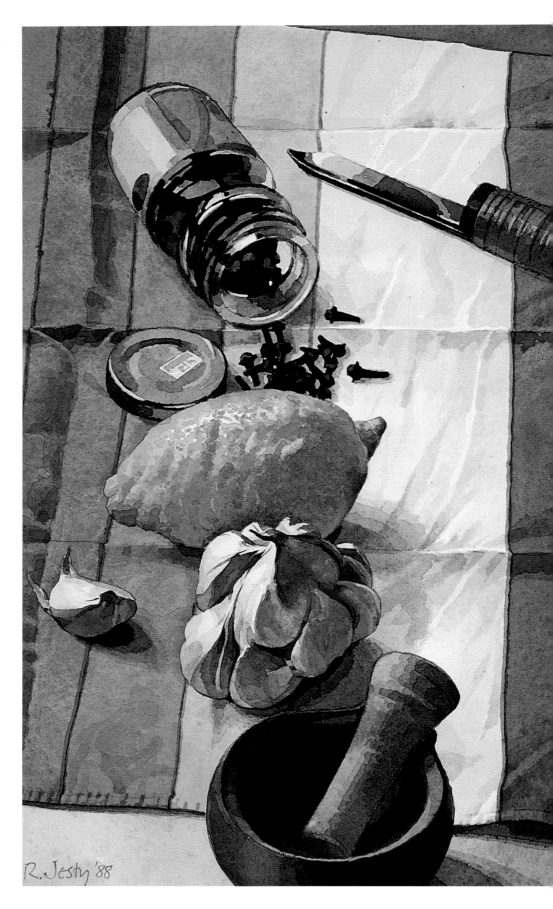

RONALD JESTY

Seeing these objects on a cloth in the kitchen immediately interested me with the visual contrasts, mainly of the surface textures and soft quality of light and shade, but also of colour and form. These qualities became the reasons for my painting, rather than just a representation of the objects themselves, and I began to consider how I could translate these features into patterns of watercolour paint on paper.

I explored some compositional ideas by means of small pencil sketches, juxtaposing the contrasting surface textures of the various objects in different arrangements – transparent glass, reflective metal, lemon peel, earthenware, etc. The conventional way of organizing such a group is to show them packed together or horizontally, as on a shelf or table top but, for me, this was too obvious and unexciting. Through further drawings the idea developed for an upright format, of the objects being 'read' from top to bottom. By turning the cloth I saw that the coloured stripes not only contained the design at each side, but also gave further emphasis to the vertical idea.

Having reached such a decision, I like to take it as far as I can, positively and without ambiguity. However, as a contrast in the design, I used the horizontal folds of the cloth and the angled potato peeler as opposing movements to the main narrow vertical theme.

When my final decisions and adjustments to the composition had been made, I prepared a full-size outline drawing which I then traced on to my watercolour paper ready for painting.

SUSAN PENDERED

In common with all painters I draw my inspiration from my life and my surroundings, and with the thoughts and images that these evoke I compose my paintings. Many artists interpret the landscape, others the human form or variations on still life, but for me, interiors, coupled with familiar, often commonplace, objects, will be the starting point for many paintings.

A recognizable style is important to me irrespective of the subject matter or the medium in which I am working, and this is achieved in part by the role colours play in my work. I aim to keep them clean, clear, bright and harmonious, exaggerating them when necessary or changing them altogether if I feel it will enhance the finished work. Light and dark contrasts are most important, as they determine the atmosphere or mood of a painting. My work is sometimes abstract and sometimes figurative, but always has elements of ambiguity as I never wish to reveal all to the onlooker, believing that one responds to works of art rather than finding it necessary to understand them.

When planning a painting my considerations are content, composition and design, colour and tonal qualities, but I am less concerned by directional light as it is often irrelevant. I am always interested in reflections and the way they often become distorted by different surfaces or when seen through other objects such as glass jars or bottles. My home has a glass partition between two rooms and it is possible to see into a third room through an open door. This produces multifaceted reflections and overlapping images of considerable complexity. These images were the starting point of *Old Chair and Aspidistra*. I began by making several drawings on the spot, then left the scene and made one drawing from my information. The chair was a problem and after various experiments it was allowed to float between the two rooms! The blue vertical lines represent a screen and some of the objects on the shelves could be described as coded symbols rather than factual representations.

▶ Susan Pendered, *Old Chair and Aspidistra*, 54.5 x 35.5 cm (21½ x 14 in), watercolour

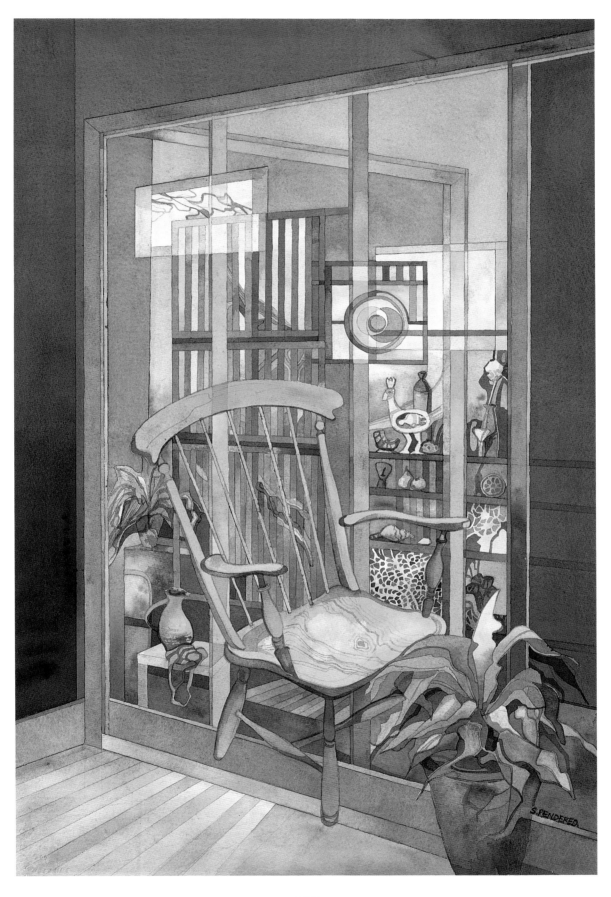

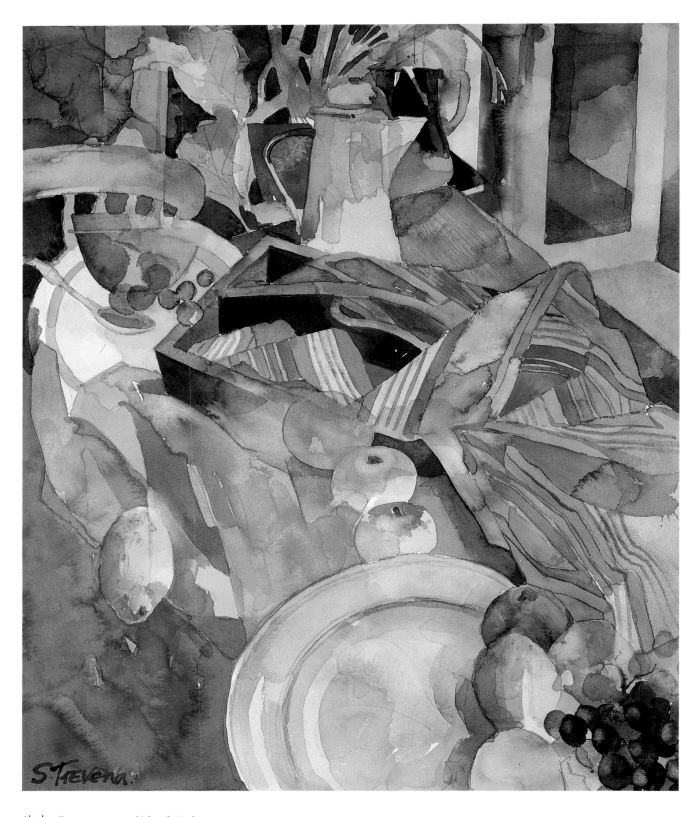

Shirley Trevena,
*Still Life with
Yellow Cloth*,
45.5 x 61 cm

(18 x 24 in),
watercolour and
gouache

SHIRLEY TREVENA

Many of my paintings begin with a desire to see certain colours together. In this painting I thought of a range of colours first and then looked for objects to embody them. In the main part of the picture I have placed three tea towels purchased from a local shop. I was in raptures over their colours and stripes, and knew that I could not fail to make an interesting painting out of them. I also bought a simple wooden shoe-box painted green that would provide the sharp angles to cut into the more organic shapes.

I work in my kitchen which has a glass roof. Because it is part kitchen and part conservatory, it provides me with wonderful background props of plants and china. This still life was set up on my kitchen table. The objects were chosen for their colour and shape, not to tell a story about what I put on my kitchen table. The spaces between all the objects have to be equally interesting and I may take a whole day over arranging things in order to achieve an exciting composition.

I paint without drawing first, to keep a fresh look. Getting the right marks means putting the paint down with conviction and speed in response to my feelings towards the sensation of seeing. This painting took me five days to complete. I had no way of predicting the final 'look' of the painting, because it is not about the objects themselves but about the process of seeing and painting them. I was far more interested in what happens when you put yellow and orange with turquoise than in how I could make apples and lemons look edible.

Doreen Roberts,
Garden Centre,
46 x 35.5 cm
(18 x 14 in),
gouache.
The grid of bricks
and window
panes was
contrasted with
the spiky foliage
to portray what
was a 'stagey'
scene.

INDEX